CHESTERFIELD
THROUGH TIME
Brian Davis

AMBERLEY PUBLISHING

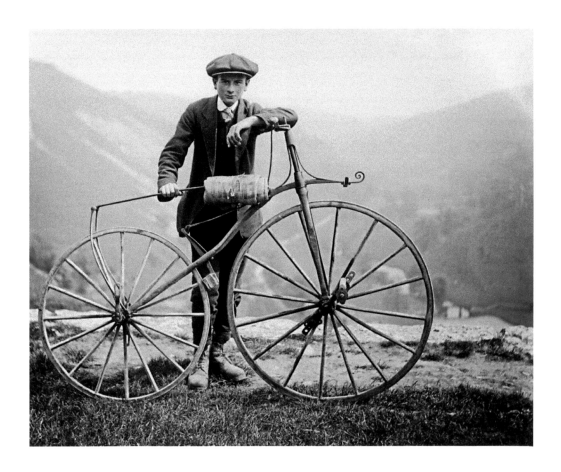

First published 2009

Amberley Publishing Plc
Cirencester Road, Chalford,
Stroud, Gloucestershire, GL6 8PE

www.amberley-books.com

Copyright © Brian Davis, 2009

The right of Brian Davis to be identified as the
Author of this work has been asserted in accordance
with the Copyrights, Designs and Patents Act 1988.

ISBN 978 1 84868 478 2

British Library Cataloguing in Publication Data.
A catalogue record for this book is available from
the British Library.

Typeset in 9.5pt on 12pt Celeste.
Typesetting by Amberley Publishing.
Printed in the UK.

Introduction

I was very pleasantly surprised when I received a telephone call asking me to undertake the production of another book on comparing old Chesterfield with the present day.

I agreed, especially after seeing a few sample pages from one from the new series, as I did feel that, with the use of colour the book did look considerably better. Only on reflection did I realise that this time it was going to be a much harder task than before, it was a mammoth task then but with time it is surprising how all that is forgotten.

Major changes occurred in Chesterfield around the turn of the century. Since then, development has considerably slowed down and, with the recession, some developments have stopped.

I have tried to look around to record changes in areas away from those used in the first book but it is not possible to record Chesterfield without including all of the historical centre of the town, and so I have had to look around the surrounding areas.

A good example of this is the development of the old Bryan Donkin works where the new B&Q unit is only partially occupied with nearly one half standing empty. The rest of the site was to be filled in with three-storey office blocks and again only the first of those have been built and that is only partially occupied. A sign of the times, but then that is what I have been asked to record.

It is also very limiting, as one empty development site is very much like another.

I have also this time included many 'old' images from within living memory, i.e. the 1970s and later, rather than going back all of the time to around the First World War. I have still used images from that period and these generally have been again from the wonderful record that Nadin compiled.

It is surprising that generally we do not record everyday life until it is disappearing or we realise that it has gone. That is the advantage of

this type of book as it makes the author record everyday scenes and they are then recorded for future generations.

The recording and saving of images for future generations is one that does concern me. Nadin in the 1920s recorded his images on glass plates and many of those are still with us. In the 1930s the corporation under Wilson, the engineer at that time, had many of the works filmed and they were 'printed' onto magic lantern slides of which there are several hundred stored by the library. I have used some of those to give a magic lantern lecture in the library lecture theatre for the County Council.

In later years the photographers recorded the images onto black and white film and again many of these are in collections or archives and all of these have a good known permanence. Many images were then recorded on colour film, whether in negative or slide versions and some of these old images have started to degrade. The only recognised archival one is Kodachrome. We are now mainly using digital and that media is altering so much that the question must be asked, will we be able to read the discs on which we save the images in ten years time? We have already gone from floppy discs to 3½" discs to CDs and now DVDs. What next?

At least the printed word and printed image should still be with us in 50 years time.

I have enjoyed putting this book together and I hope that it gives plenty of enjoyment, and that you will save it for years to come so that you can look back on what Chesterfield was like in 2009.

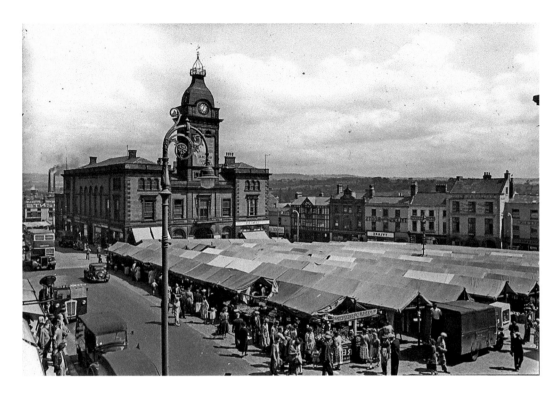

The Market Square

The Market Hall is the centre of the shopping and commercial area. The hall was built in 1857 and has been the main feature of this section of the town. Chesterfield market still has special events frequently being held in the area, as well as the market. Between these two images the tower lost its domed top, but it has been retiled and returned to give the hall its majestic appearance.

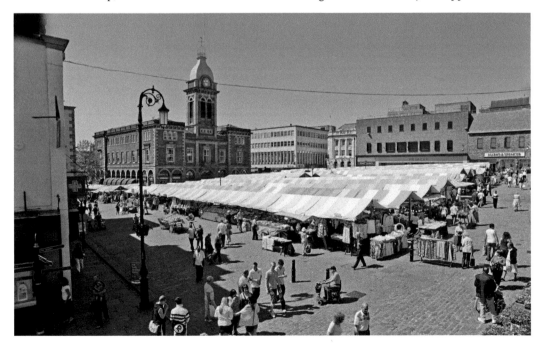

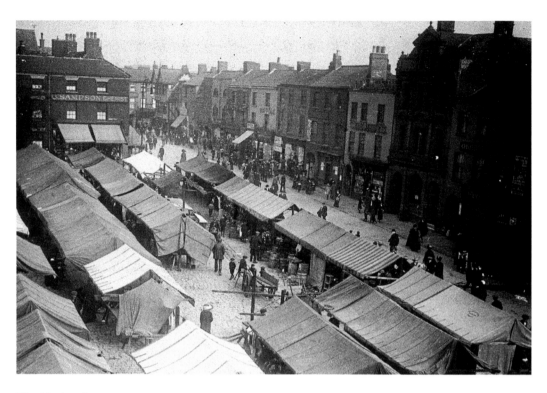

The Market Square

The view from the balcony of the market hall has not altered substantially over the years. The stalls are closer together although these days with the current recession many are now unfortunately empty. The two pictures show clearly how the elevations of the shops and offices to Low Pavement have been preserved by the modern development behind.

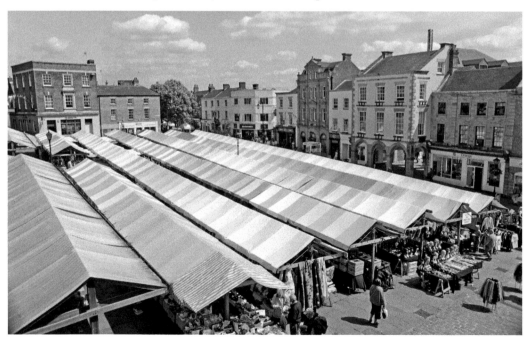

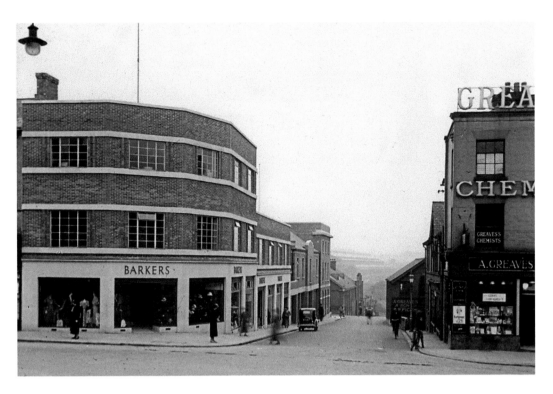

Tontine Road

Working around the square we have the position where Tontine Road initially came into Low Pavement. The building on the right was Greaves the Chemist and it is now Boots. Barkers the furniture store is now MacDonald's. The road no longer exists as it has been closed at the south end by our library.

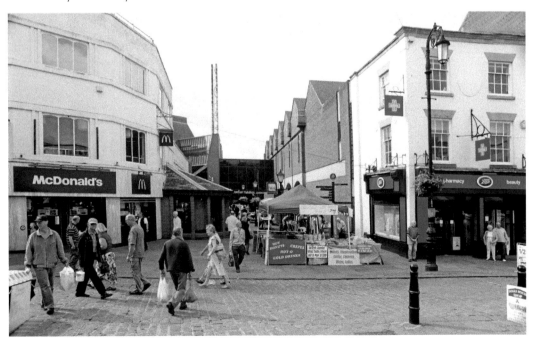

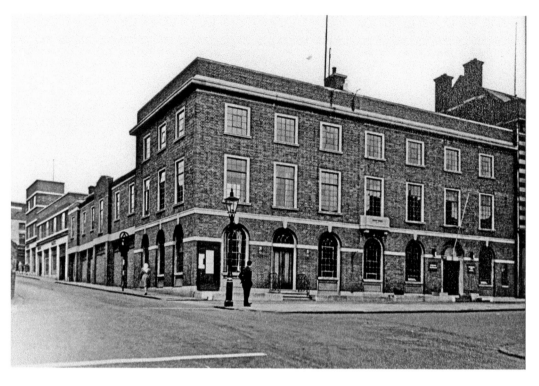

Tontine Road / Beetwell Street

Before leaving Tontine Road we will look at the south end where we now have the back of the library, which replaced the Fire Station and the Police Station. These have been enlarged and extended over the years but were both destined to be moved to modern premises, although in the case of the fire service these were also dated.

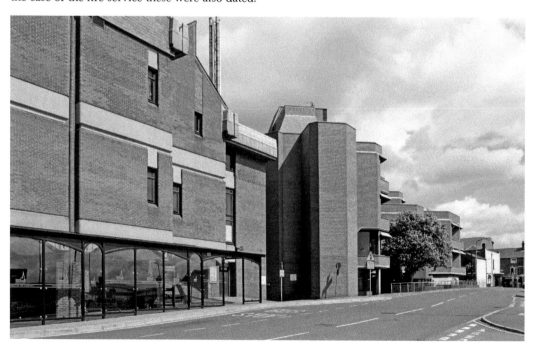

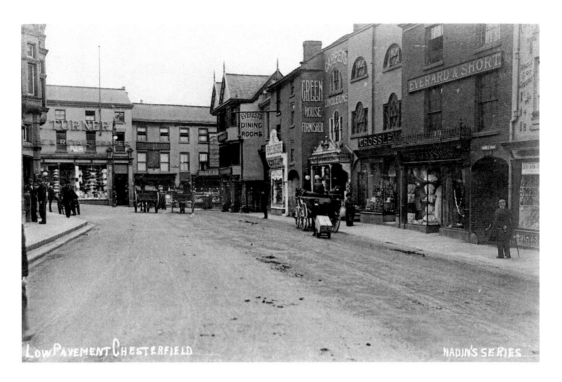

Low Pavement

Back to the market square, the view along Low Pavement to the east is now a very busy market and shopping area at the weekends and has become an extension of the Market Square. The end was closed in and opened up to what was Vicar Lane, which in itself become absorbed into the Vicar Lane shopping development. The main feature coming through the years is the Falcon public house which is no longer a pub but a building society.

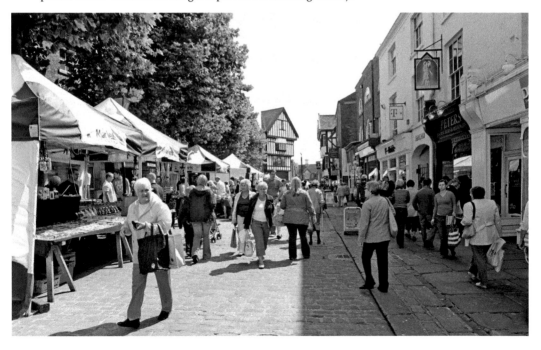

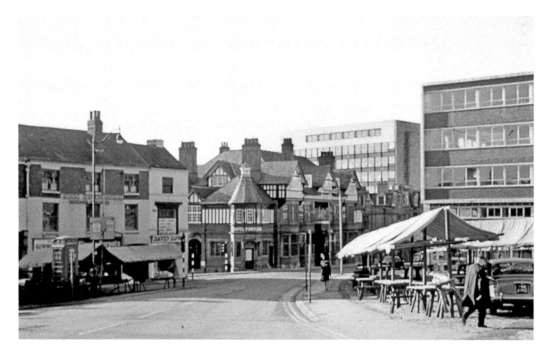

New Square

At the rear of the market hall is New Square and when I first moved to Chesterfield my office was at the bottom of the square immediately opposite the underground toilets. The road ran right through the centre. The area is now a fully pedestrianised area and is an extension to the main market and also is used for events and, quite often at weekends, entertainers like the band on the small image.

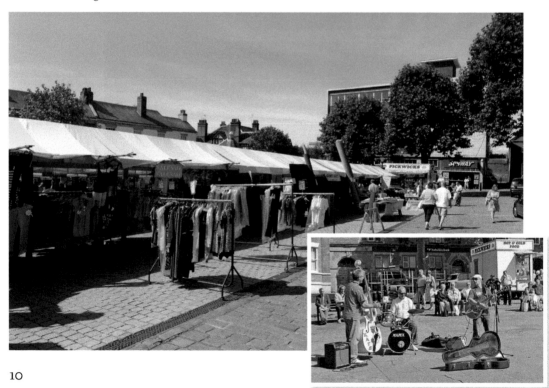

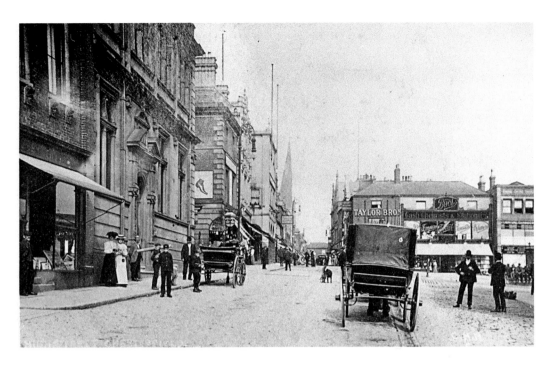

The High Street

Looking east from the north side of the market hall the road layout has not altered much over the years but the usages of some of the buildings have altered. The market square is still the main feature with the large stores playing a secondary but essential part of this vibrant area. An excellent framed view of the other symbol of Chesterfield, St Mary and All Saints Church or, as it is better known, the crooked spire, is also seen down the High Street.

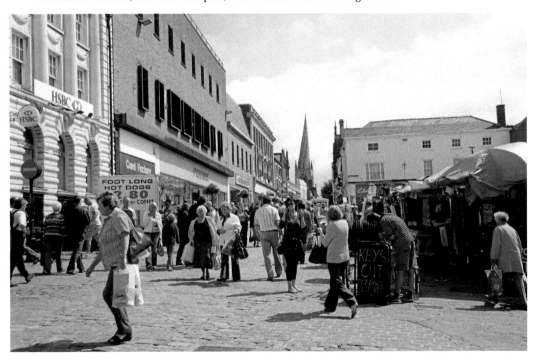

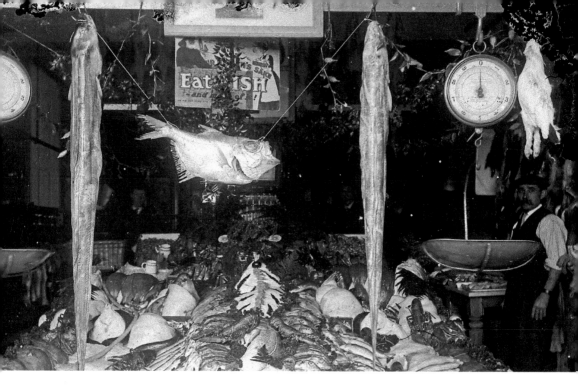

Market Stalls

We cannot leave the market square without looking at the stalls and use of the square as a commercial area. The earlier image, of 1890, shows a fish stall, a method of selling that I had not seen on our market until only a few days before I finished this book for the publisher – a fish stall was back again. The present day goods are more colourful and quite varied. The market day with all of the stalls occupied is the Thursday Flea Market, at the moment, which could be a sign of the recession, or the television programmes that are valuing items, people having bought as a bargain only to find that they are worth hundreds of pounds.

Vicar Lane

The Vicar Lane area was substantially altered with the new development in 2000 and we all soon forget what was there before. Looking east from Packers Row the new buildings are further forward than the old road as shown by the front of the Wilkinson's shop, which had been a Fine Fare before they took it over. Next door was the Grosvenor Room – one of the locations used by local organisations for annual dinners and the like. I remember hearing Eric Varley, our MP and later chairman of Coalite, give an 'after dinner' speech here.

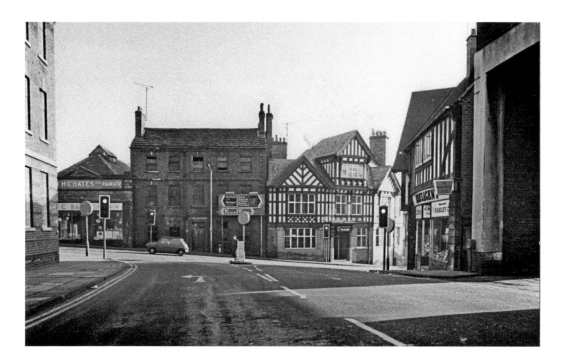

Vicar Lane

At the other end of Vicar Lane was the old Chesterfield Bus Station, which for many years was not used and had itself replaced an old school building. The road went through to St Mary's Gate with an unrestricted view of the old Saltergate brewery offices, which are in a listed building. The road is now closed and bollards stop its daily use with the restaurant section of the British Home Stores blocking the view although the old brewery offices are still just visible through the archway.

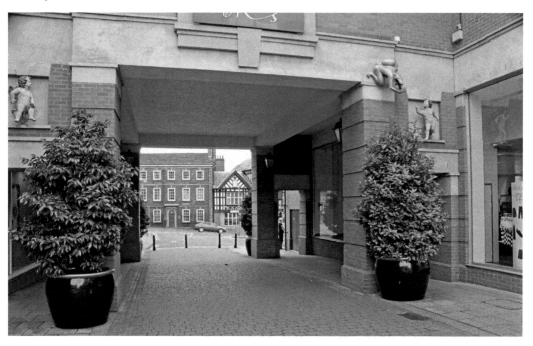

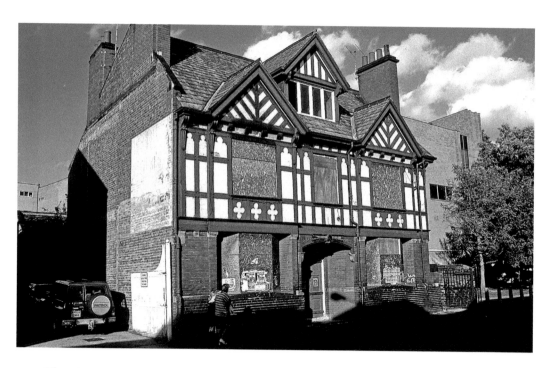

Vicar Lane

The Red Lion public house had stood in Vicar Lane from when it was rebuilt in 1920 until it was closed in 1989, but it was still there in 1995 awaiting the start of the new development. The use of that site has gone from one drug to another.

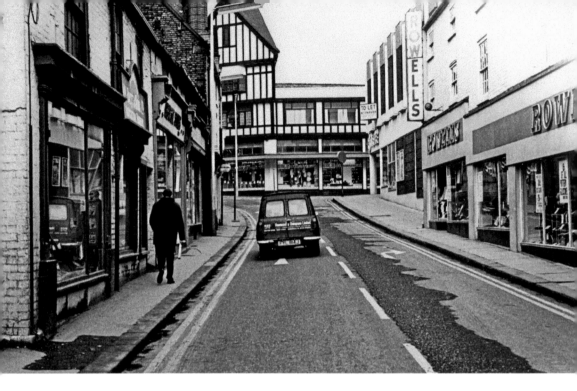

South Street

Looking up South Street from Beetwell Street the left-hand side has all been modernised and the right-hand side absorbed into the Wilko's store. We used to buy our wallpapers from the store on the right in the 1970s image. The listed turret on the old Turners building fills the end of the street view.

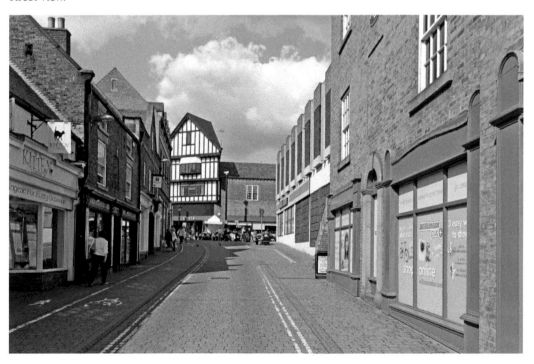

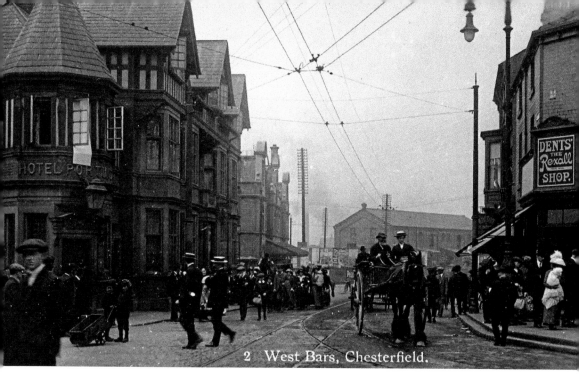

2 West Bars, Chesterfield.

West Bars

West Bars was very much a tree-lined area leading out to Chatsworth Road and all points west. It starts at the Portland Hotel, which stood side by side with the Lancashire, Derbyshire and East Coast Railway station, and the 1900 image quite clearly shows the station and its warehouse behind with the original Dents shops on the right. This end is now traffic-free from 10 a.m. most days and New Square outside Dents makes a good seating area to get relief from shopping on the few good summer days that we get.

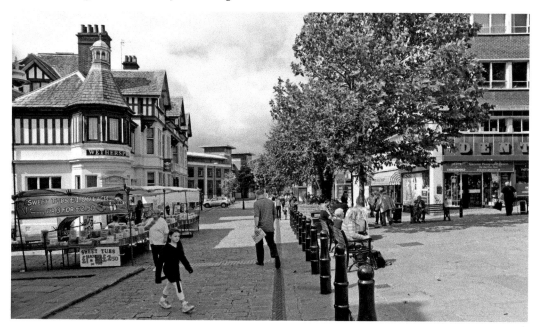

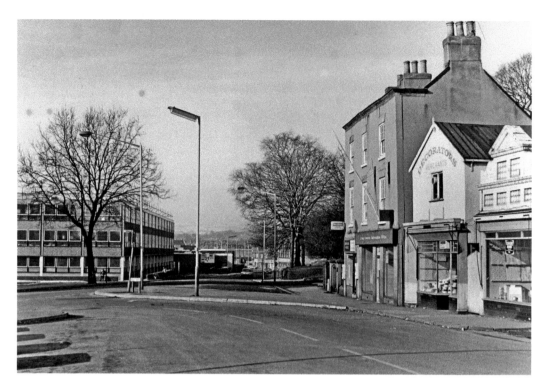

West Bars

Further along West Bars was the very bland 1950s AGD building, which was on the old railway property. This building was removed a few years ago and replaced with the new structure although the ancillary buildings, which had housed the sorting office, still remain.

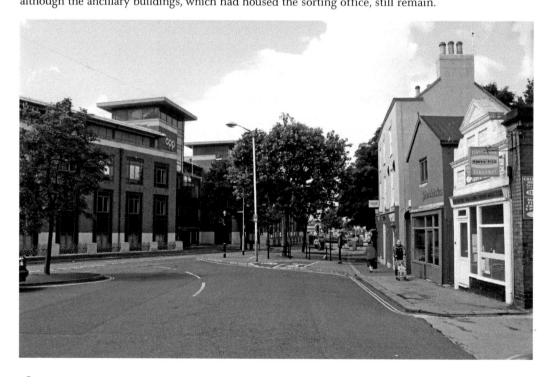

West Bars

In 1917 West Bars was mainly domestic with fifty houses being listed with extra ones in the Star & Garter yard. These have over the years all been swept away, with many of the houses being occupied by shops or demolished. One block of houses were replaced with the concrete car park for the original AGD structure. This has been disused for several years since the building of the new AGD. It was sold two years ago by tender and, from the price paid, I suspect that it was bought for housing again. A complete circle. However it still stands empty but at least it is partially screened by the trees that have grown up.

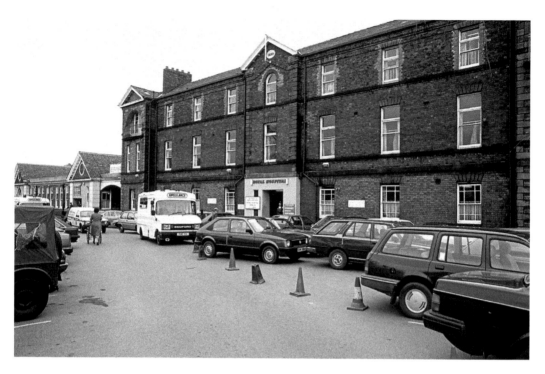

The Old Royal Hospital

The main building of the old Royal Hospital is still with us and the 1984 picture is one of a series that I took just before it closed and moved up to the present site at Calow. The building was initially converted for the sole use of Kenning Car Hire, which was later taken over by Sixt. When I called at the building to ask permission to take a photograph from within the site I was surprised to find that it was now largely being rented by the NHS. The staff there was not aware that they were in the old hospital. How memories fade. The congested old site is all forgotten.

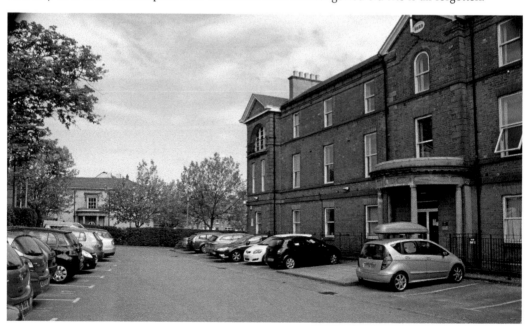

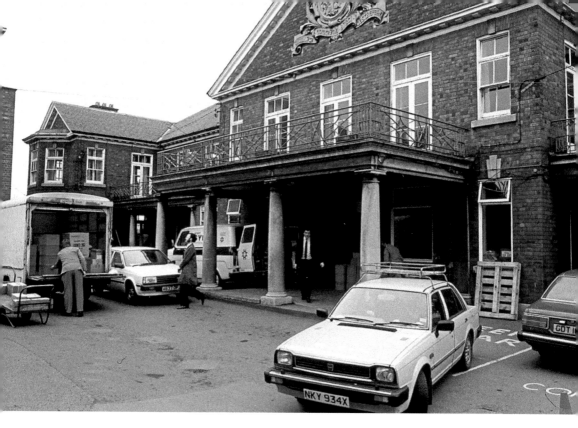

The Old Royal Hospital

The site was heavily congested and the building run-down while the site was being used as a support building. The building was unused for another ten years before redevelopment started. This has now been replaced with some modern office blocks which, whilst pleasant, do not have the same architectural appeal of the old buildings. The crest off the old building and the stone columns have been included in one of the new buildings but unfortunately the crest is under the canopy and mainly below ground level so that it is difficult to see. An opportunity lost.

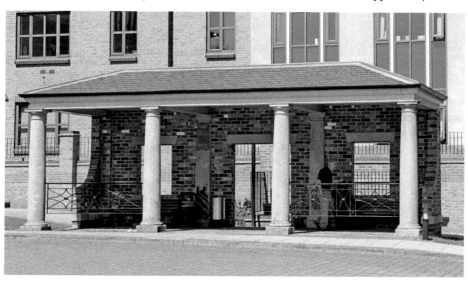

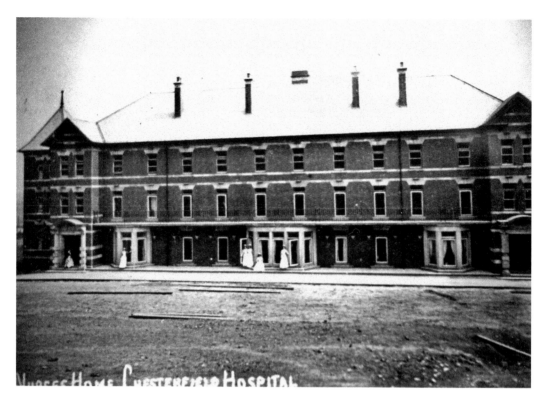

The Old Royal Hospital

At the bottom of the site was the nurse's home It had a tennis court in front of it in 1984, just before it was demolished, and it was obviously still being used as there were curtains up at the windows. This building had not altered from 1900 on the old image. This has now all been replaced by the modern office building, with a large car park replacing the sporting facilities.

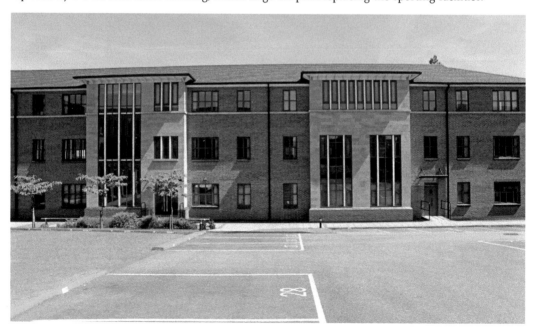

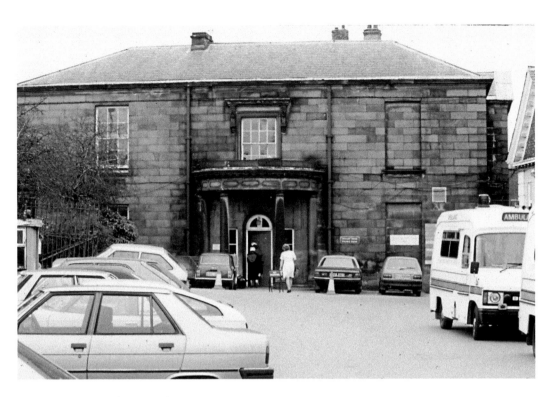

The Old Royal Hospital

The last remaining building from the old hospital is the 'Doctors House' which is a listed building and was very much in use in 1984. The building has been cleaned up and is still in use by the medical profession.

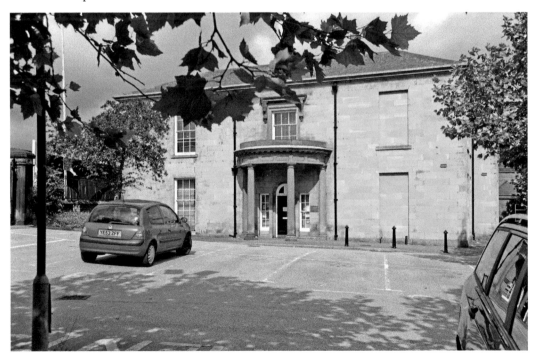

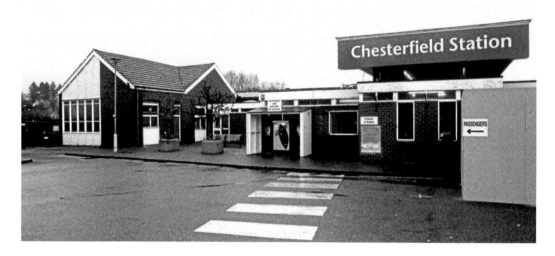

The Railway Station

The station was rebuilt around the Millennium and it is now a very pleasant airy space with seating in the atrium area, which is far more pleasant than the small waiting rooms on the platforms. The old piecemeal frontage has all gone and the 2000 picture shows the front at the start of the rebuilding which was undertaken in sections and during that time the subway was out of action and we had a temporary bridge over the tracks. It was not the elegant footbridge that the Victorians put over the tracks but a very utilitarian one.

George Stephenson, one of the engineers who designed the North Midland Railway, retired to the town and was eventually buried at Holy Trinity Church a few hundred yards from the station. He is now back at the railway, albeit in the form of a bronze statue.

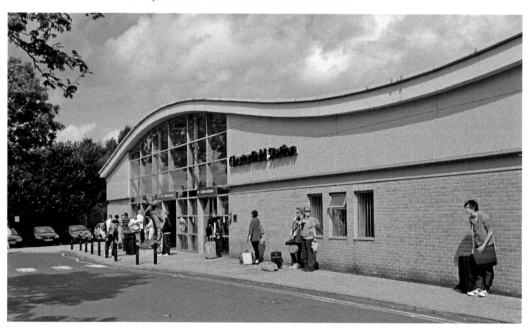

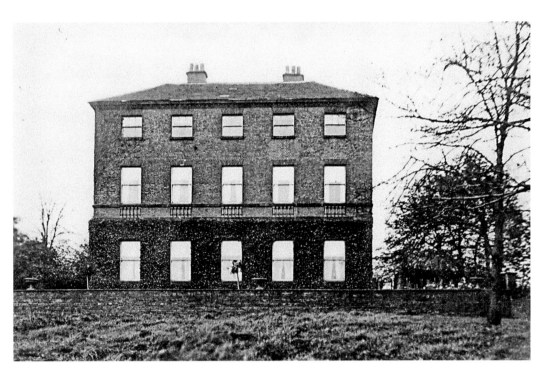

The Town Hall

The road Rosehill gets its name from the house that stood there before the building of the Town Hall. The 1920 photograph shows the old building which was a very pleasant Georgian townhouse and town hall follows the same style.

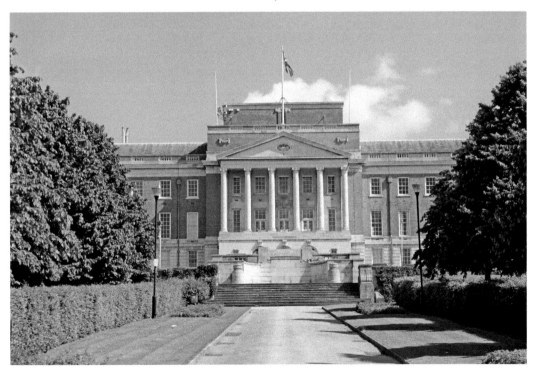

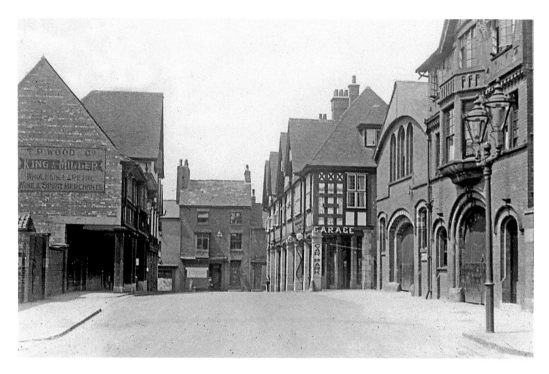

Knifesmithgate

The current town hall was built by the council and completed in 1937. At that time Knifesmithgate was extended to give direct access to it, with the Marquis of Hartington public house being demolished. The building we now know as the Queens Head was already there, although it was a garage at that time. We visited it frequently when it had a Berni steak house upstairs. In those days the Home Brewery had an agreement with the steak house chain. On Saturdays they used to serve up fresh hot scones with cream and coffees with cream floating on the top.

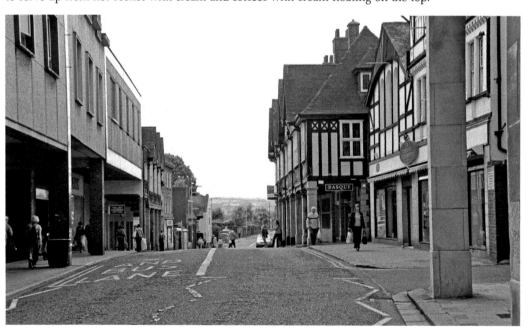

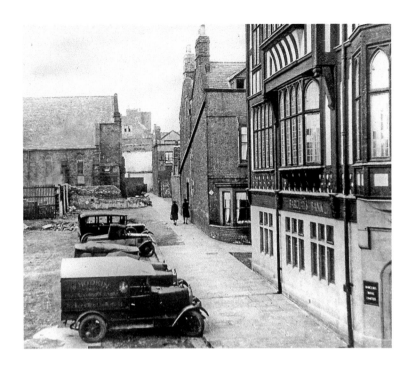

Elder Way

Elder Way is a busy part of the retail centre of the Borough and was the subject of redevelopment at the same time that the council offices were being built and Knifesmithgate being widened. Barclays Bank were already established in the corner of the cinema, and they were still there when I moved my account to that branch. They have now moved and that section is still used for financial services. The old chapel, at the rear left of the old image, which had been used as a warehouse by Crow's, was to disappear under the new Co-Operative building.

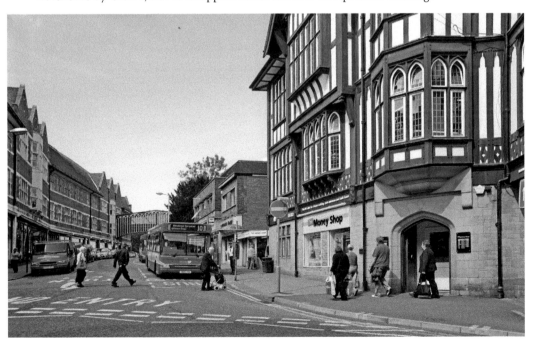

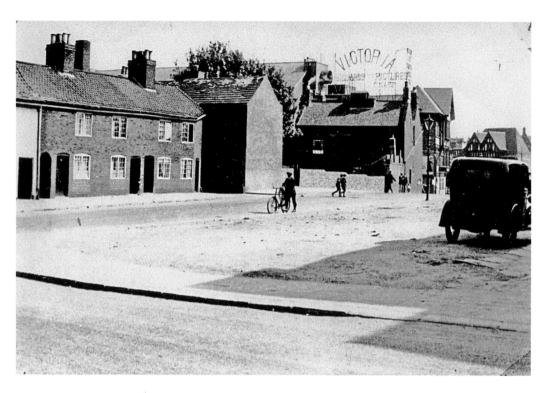

Elder Way

The view looking south down Elder Way has changed from 1936 but the trees obscure the frontage to Knifesmithgate and all of the cottages have disappeared under the Co-Operative store food hall extension with the distinctive bridge link over the road.

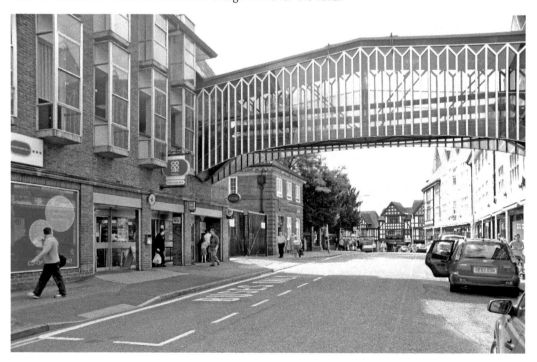

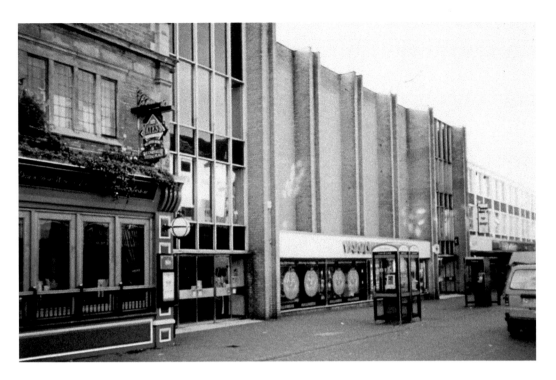

Burlington Street

Woolworth's had its entrance for shoppers on Burlington Street, with its goods entrance being at the rear from Church Lane, but with the coming of the Vicar Lane development that was all to alter with the shop moving further down the hill. Where the building was, is now the extension of Steeplegate giving access from the north into the development, and the rather stark façade has been replaced with more vernacular style architecture.

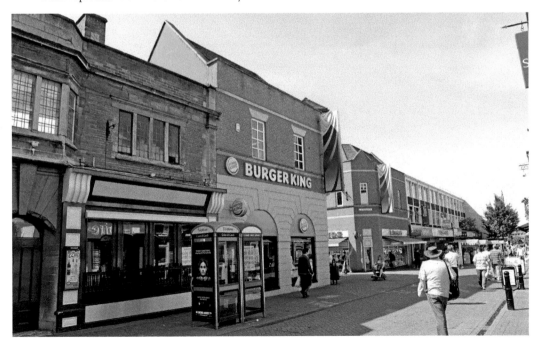

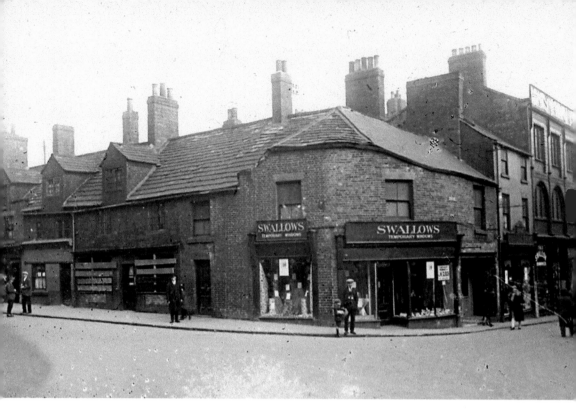

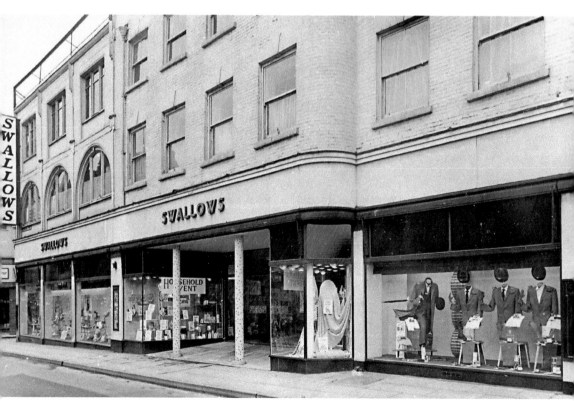

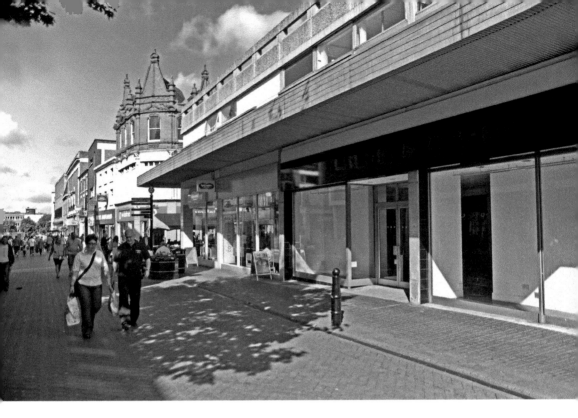

Burlington Street

Further down Burlington Street was the location of one of the two local department stores, both of which have disappeared. The Swallows building had been rebuilt in the 1930s and they had extended for the full depth of the block onto Knifesmithgate. The building was not to last all that long as it was swept away in the 1950s for the rather ugly concrete building that is there today. But then at that time the architects thought that the straight lines of concrete were beautiful? The original photograph shows the store in about 1890; the 1930s image shows how it had expanded in the intervening years.

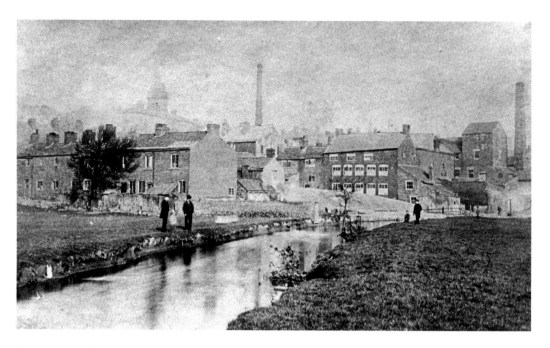

The River Rother

The 1900 picture shows how small the centre of Chesterfield was at that time and how rural it appeared to be, although it was hiding the squalor of the housing on the other side of the River Rother. This was taken from about where Focus is now and other than for Queens Park the green strip on the south of the town has all disappeared.

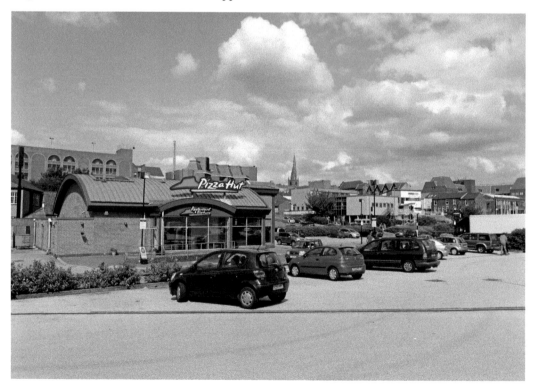

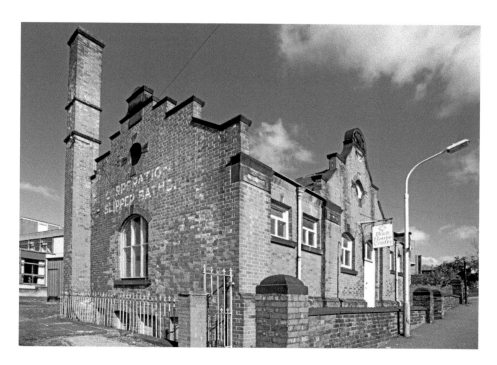

South Street

The old slipper baths at the bottom of South Street stood there for nearly 100 years, having been a very important asset to the town when they were built as many of the houses did not have hot or even running water. It stood empty for many years but it did get rented out from time to time for occasional use. It was to disappear at the turn of the century and the new dental laboratory was erected in a rather stark design. The building may not stand the test of time as had the old building.

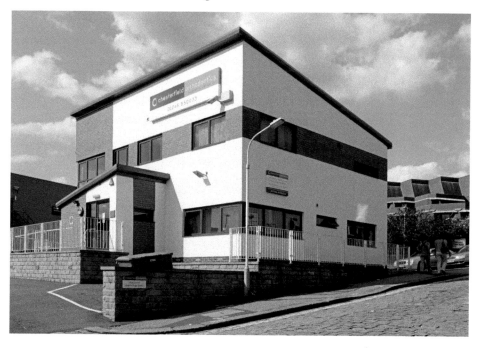

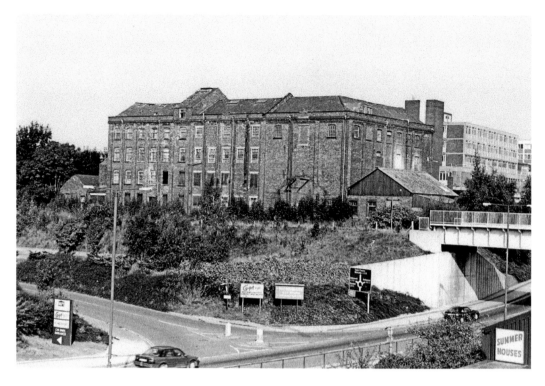

Markham Road

At the east end of Markham Road stood Wheatbridge Mills, which was the commercial base of Irving's the corn and seed merchants and a rather imposing warehouse on the approach to the town from the south. This has now been replaced with two crinkly tin retail shopping units which do not have the same imposing feeling.

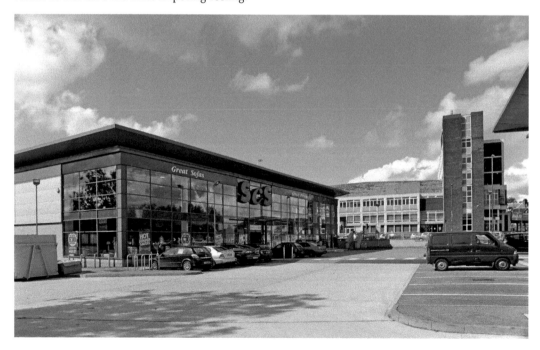

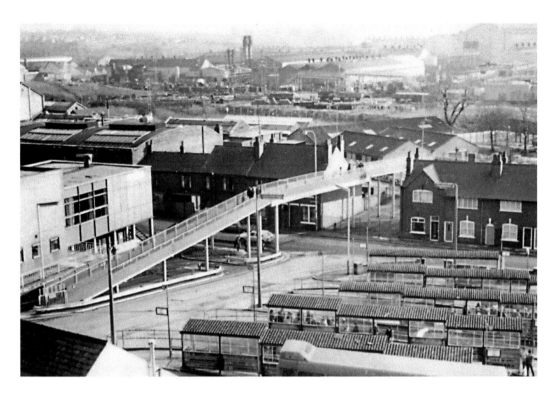

Markham Road

The change to the south of Markham Road is clearly seen in this picture taken from the roof of the Beetwell Street multi-storey car park. They do have their advantages. The temporary footbridge from the car park on what had been part of the abattoir and is now the Ravenside Retail Park is clearly seen – it was a bridge that we used every Saturday when we went shopping in the town at that time. The old canopies of the bus shelters can also be seen.

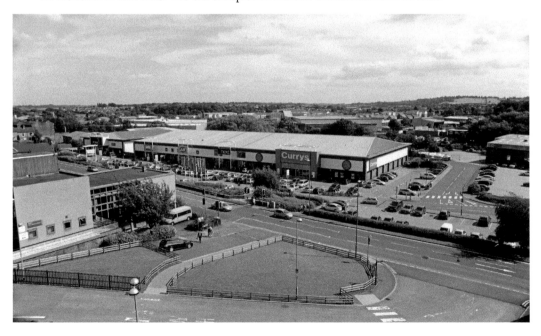

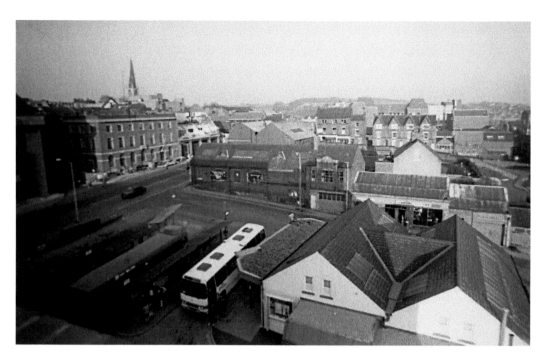

The Coach Station

Another view from the top of the car park again shows the change to the coach station area. Tontine Road ran down the eastern side of the station and in the middle was a newsagent and café. The building at the north end, I understand, had at one time been the fire station and the garage-style doors on the side appears to confirm this.

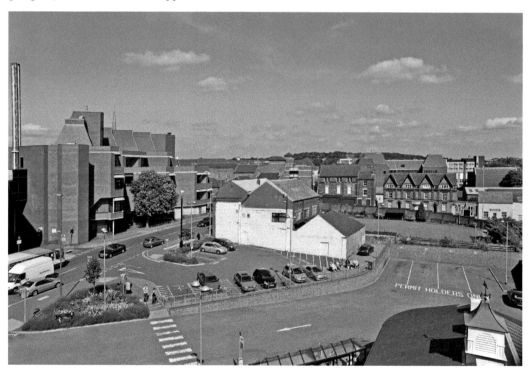

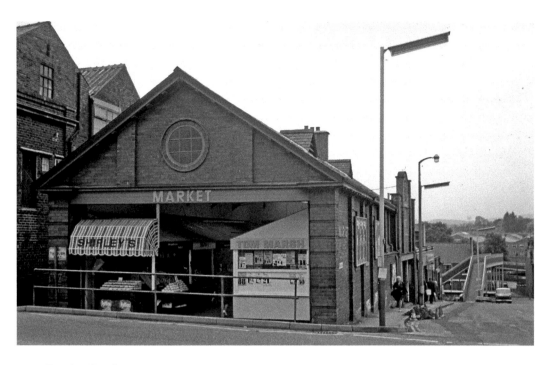

Tontine Road

Tontine Road has now completely disappeared with part going under the Pavements and the rest being lost in the new bus station. This building housed part of the market in 1970 although at one time in its history it had been the fire station. The area is now the short-stay car park for the Bus Station.

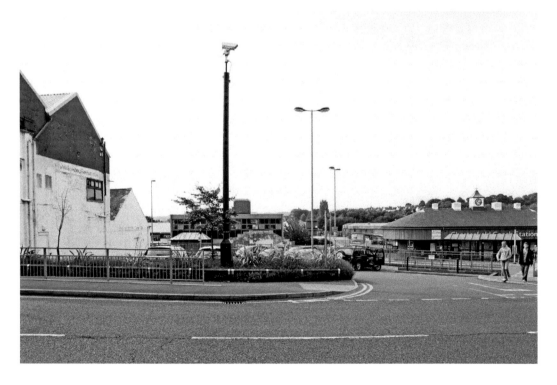

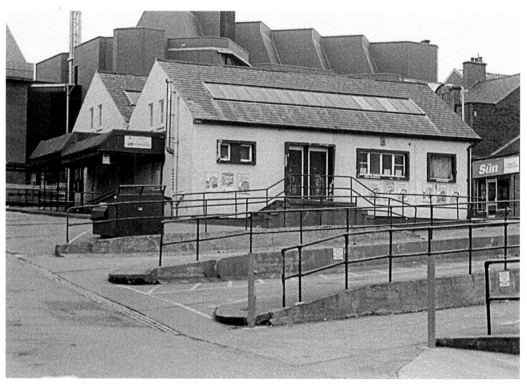

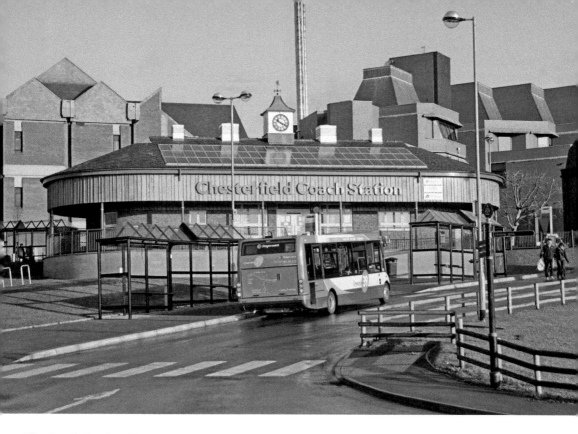

The Coach Station Site

The Coach Station had been in need of redevelopment for many years and this has now been completed with an impressive and functional building that will serve the town well, although it has pushed the local buses onto road-side stops on Beetwell Street, the station serves inter town services. The station sits on the site of the old 'dog kennels' which was the name given to the old slums that stretched down from below Beetwell Street towards the River Rother.

Beetwell Street

Behind Low Pavement stood the old post office sorting department. It had been demolished when this shot was taken in the 1970s, giving a clear view of the back of the buildings along Low Pavement. The area then was an open car parking area. It has now all been filled-in as part of the Pavements development, with the buildings along Low Pavement having only their frontages retained.

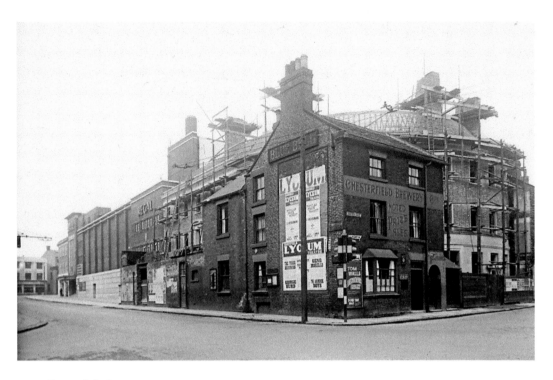

Cavendish Street

The Blue Bell public house was rebuilt as part of the redevelopment of the site and the building of the Regal Cinema. In 1935 it still existed. By 1936 it was all-change with the cinema and the new public house being erected behind the existing frontage so that the road could also be widened.

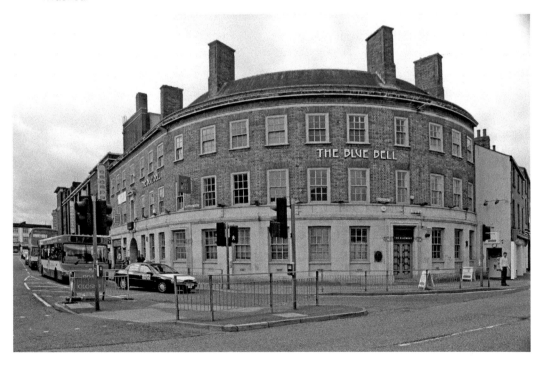

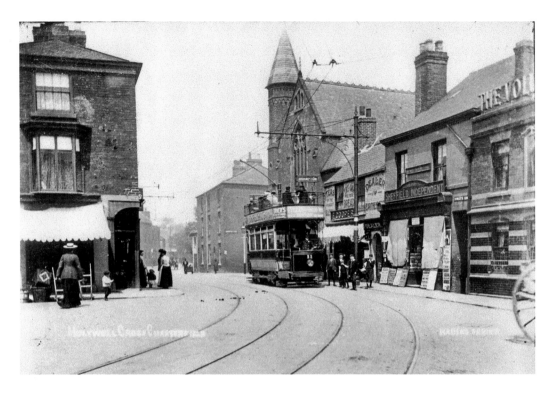

Holywell Street

Looking west along Holywell Street shows how this whole area has been widened to improve traffic flow and how traffic signals now fill the area. The old Methodist church still stands out well, although that changed to become the YMCA and it is now yet another night club. Public transport still run through the streets but the old trams are now replaced with low modern sleek buses.

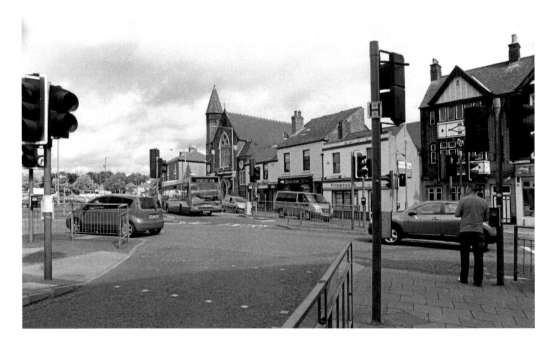

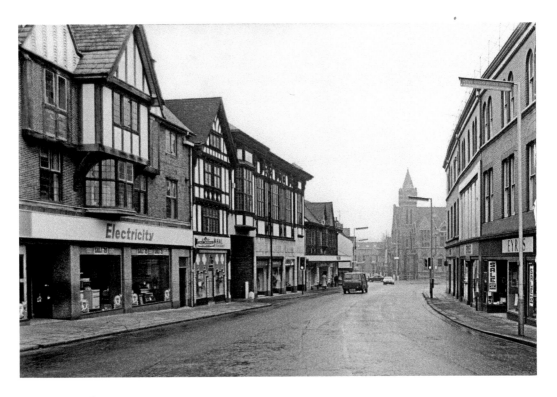

Holywell Street

Looking east along Holywell Street, the view has not changed much in the last forty years but the uses of the buildings have. The Odeon cinema is, at least, still used for public entertainment being owned by the Borough Council as the 'Winding Wheel'. The electricity showroom is now closed and is yet another nightclub.

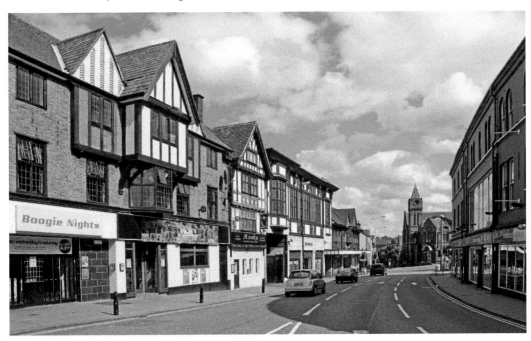

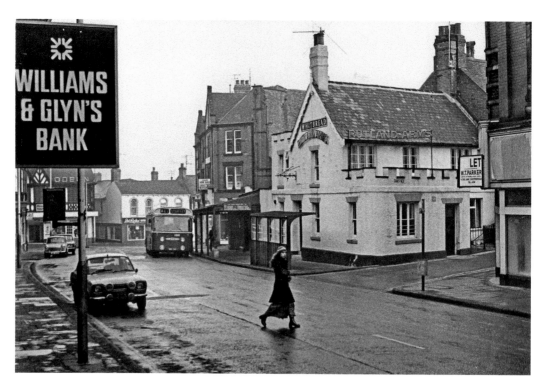

Stephenson Place

Stephenson Place is still a busy shopping area in the Borough with it also being a drop-off and pick-up place for buses. William & Glyn's Bank has been absorbed in to the Royal Bank of Scotland. The Rutland Hotel is still trading.

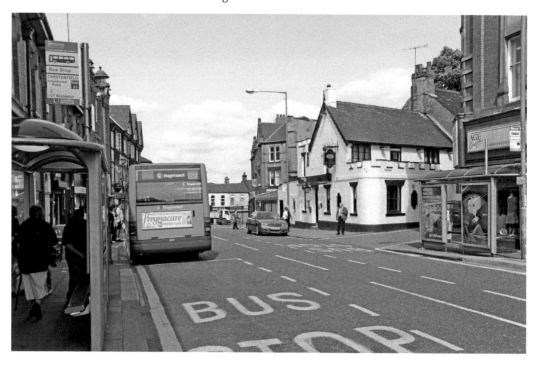

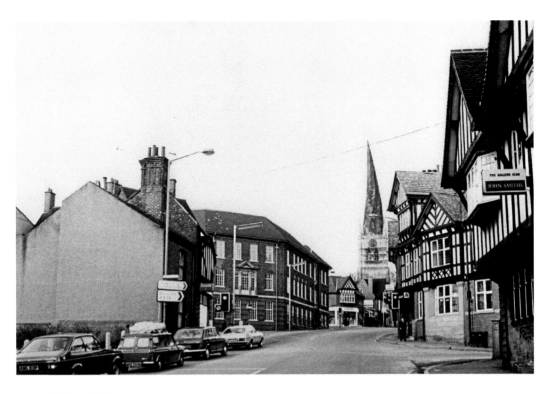

St Mary's Gate

St Mary's Gate is an extension of Lordsmill Street, being the main approach to the town from the south and the upper length has not altered in appearance since the 1970s but again the use of the buildings have altered.

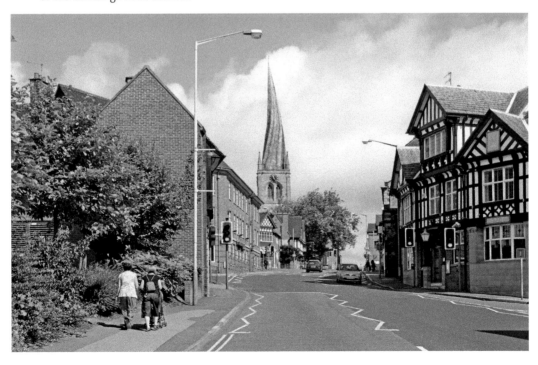

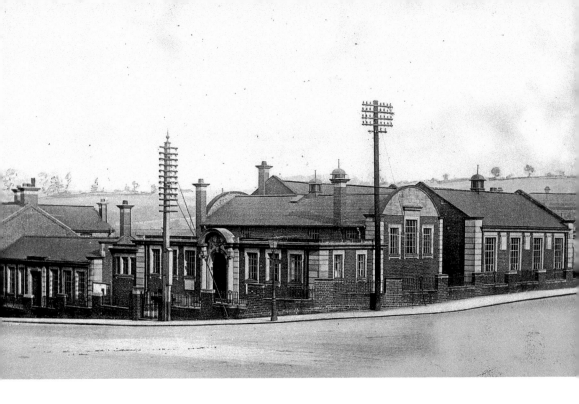

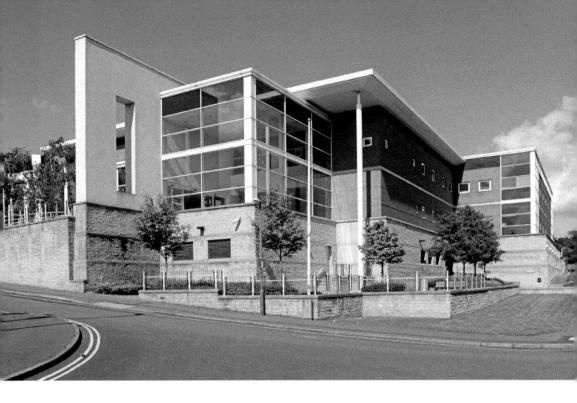

The Magistrates Courts

The Magistrates Court has also moved around the borough a large number of times, from Beetwell Street to Malkin Street, to West Bars and recently to Durrant Road. With each move the building has increased in size and become more impressive, although the 1970s version in West Bars is very impressive, having been designed to look like a book on its side, and is now a listed building. Although it is no longer used as a court it cannot be demolished, and I understand it has roof problems. It is now available for rent on a room to room basis and is being used by some sections of the authorities for various services.

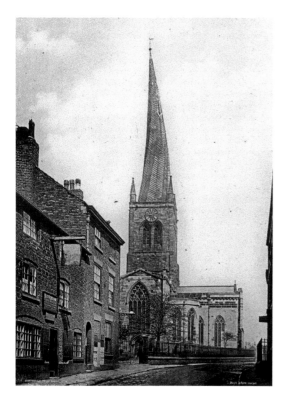

St Mary and All Saints Parish Church

We cannot leave the centre of Chesterfield without looking at 'the Crooked Spire' or, to give the building its correct name, St Mary and All Saints Parish Church. Its famous spire is nearly 3m out of the vertical. The building has not altered over the years, unlike its surroundings.

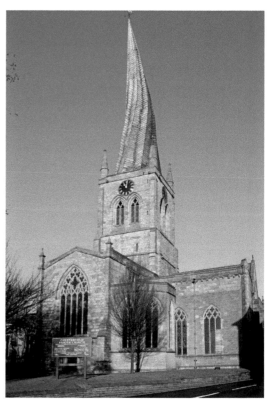

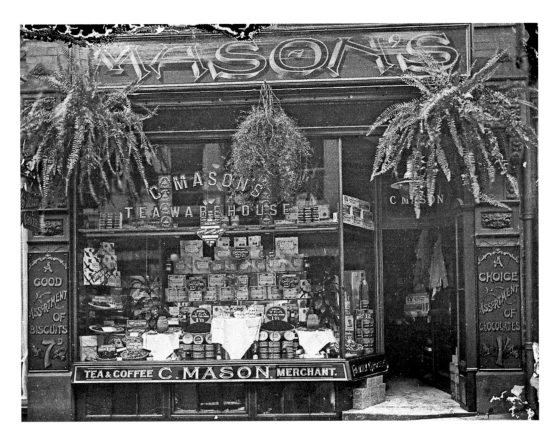

Tea Shops

C. Mason's shop was listed in 1917 as being in Packers Row not far from where Greenwoods are today. A specialised tea and coffee shop is not very common, although we in Chesterfield do still have one in the Northern Tea Merchants in Chatsworth Road. Similar specialised shops have disappeared in most towns and cities with the advent of the multiple choices of beverages that are available in the supermarkets.

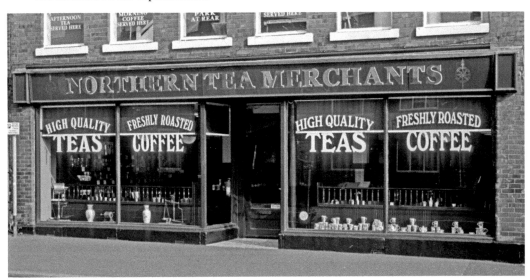

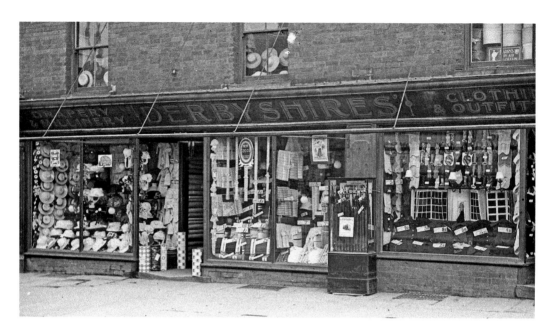

Clothing Shops

Shopping has been and is still a very important part of the economy of the town, and retail therapy has become a part of our daily life. This obviously varies from the essential activity of food buying through to the purchae of luxury goods, some of which we now take as being essential. Many of you will remember the days without a television.

The shop displays in around 1910 were very cluttered and did not appear to be set out in any order. This is clearly indicated in the photograph of Derbyshires' shop, which had a very varied stock from millinery through to trousers and umbrellas. The modern Greenwoods shop, on Packers Row, whilst partially obscured by large posters, has a much more simple display to show the goods off to the best advantage.

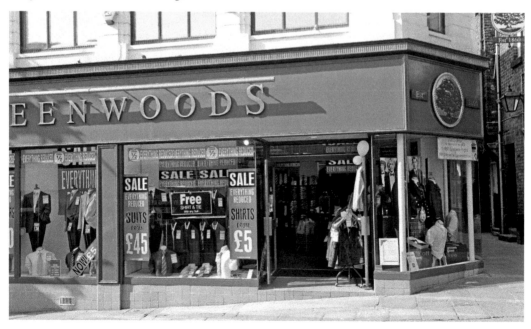

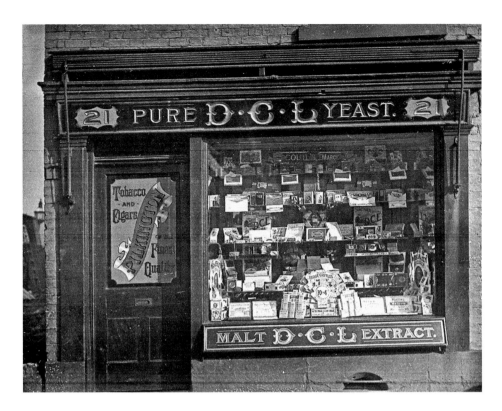

Shops

Another example of the specialist shops were yeast shops. This is a product that would be hard to find today, yet in 1917 there were two specialist shops in Chesterfield selling yeast. One of the unfortunate occurrences of this age is the empty shop, of which there are many around the town including the large unit in Vicar Lane that was occupied by Woolworth's and is soon to become H&M.

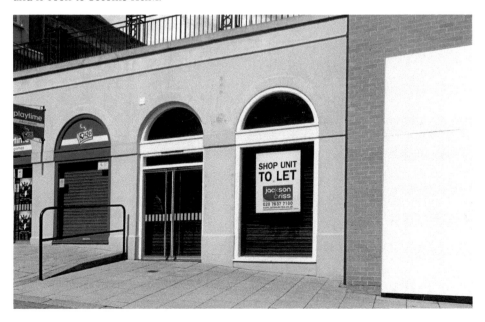

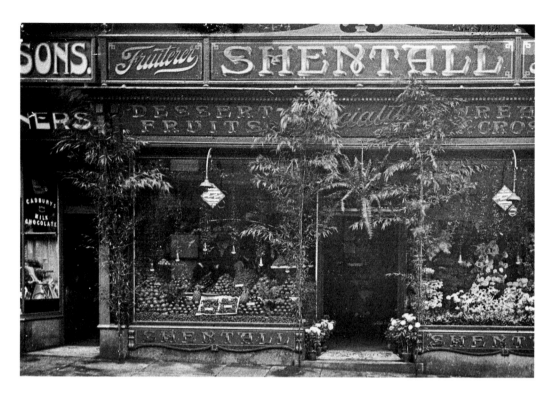

Florists

Against this we have several examples of retailers who have been in the town for many years. One of these is A. Shentall who in 1917 was listed as being in Glumangate as a fruiterer and is still trading as a florist today, proudly displaying on his signage as being established in 1870. Strange as it may seem no flower shops were listed in 1917.

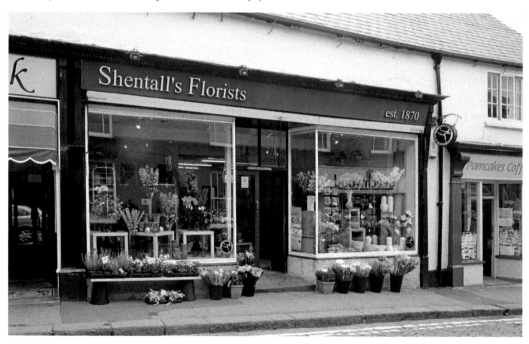

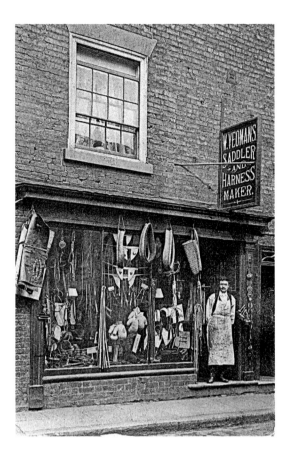

Yeomans

Another long-established Chesterfield firm is Yeomans, who started just over 100 years ago in 1904 and was still in the same family until a few years ago. They started as a saddler and harness maker and were still listed as this in 1917, then over the years changed to an Army Stores selling ex-army clothes. The image and focus has now changed to camping and outdoors, which shows that shops have to change to remain in business.

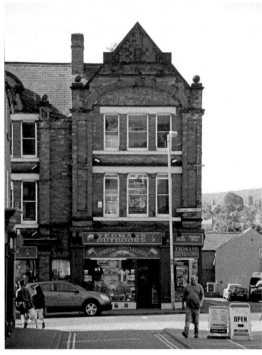

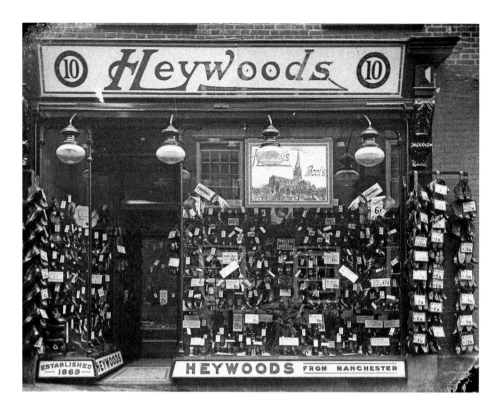

Shoe Shops

Another shop that was in Packers Row in 1917 was Heywoods and they were listed as a boot and shoe retailer. Whilst the shop fronts themselves were very decorative, which was the style of the period, the windows were again very cluttered, what with the more simple architectural features of today the window displays are more attractive to our modern eyes.

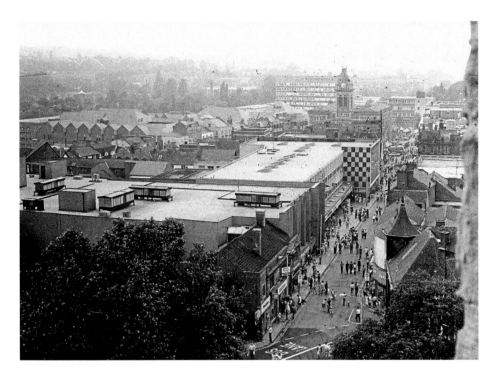

View From 'The Crooked Spire'
Looking west we have the market hall as the central feature and the checkerboard end of the 1950s building on High Street has now gone. Another dominant building that has also disappeared is the old AGD building of the Post Office. The new building harmonies better into the townscape. I understand that the original 1950s building had 'concrete cancer' and had to be demolished.

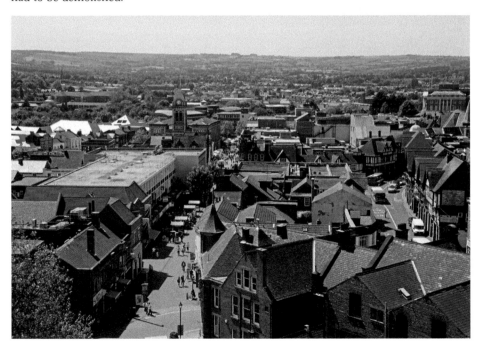

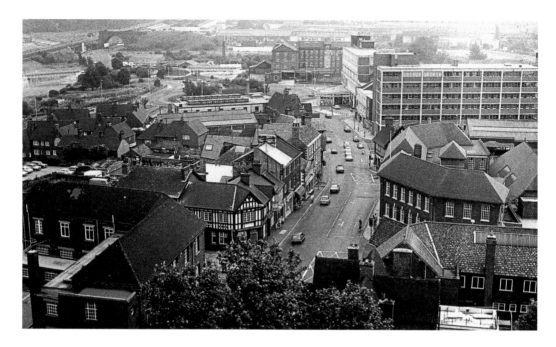

View From 'The Crooked Spire'

The balcony up on the Crooked Spire is a excellent location for looking out over the town. The various changes can be seen although it is mainly a roofscape with the nearer buildings often obscuring the further ones. Now, due to health and safety regulations, it is not possible to walk all the way round with only two sides now being accessible to the public.

Looking south in 1983 the work on the new bypass was not apparent, but a year later the work was clearly underway. Wheatbridge Mills was filling the view at the end of St Mary's Gate with Bryan Donkin behind. All this is now gone with some crinkly tin sheds replacing the old brick warehouse and housing, and the B&Q store now filling the Bryan Donkin site.

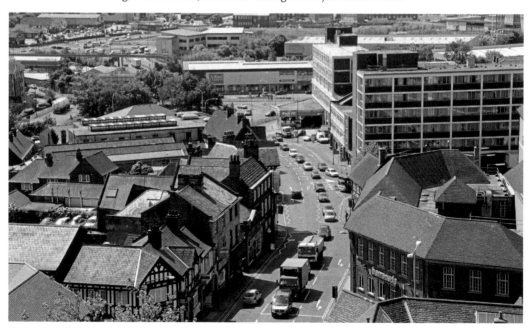

View From 'The Crooked Spire'
Another pair of images looking west. These show the Alpine Gardens and the change in the use of this area which is now partially occupied by our Tourist Information Office. It is a hard paved area but does incorporate seats so that shoppers can as least get a rest, if not peace and quiet, as buses pass the area at frequent intervals and they do have a very deep engine noise!

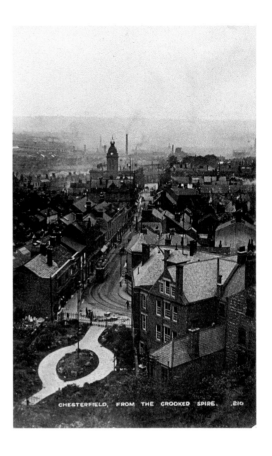

CHESTERFIELD, FROM THE CROOKED SPIRE, .210

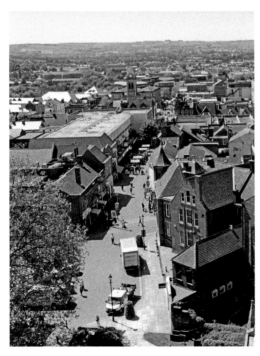

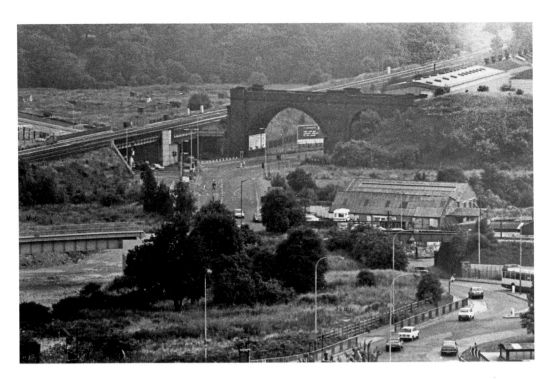

View From 'The Crooked Spire'

Looking south we have a close up of the Horns Bridge area showing, in 1984, the old bridge still standing and the Tube Works in the background, with the new bypass under construction. This has all been swept away with the regeneration that has occurred in the area. Although it does not give the depth of employment previously experienced there it is, nevertheless, employment for some and enjoyment for others.

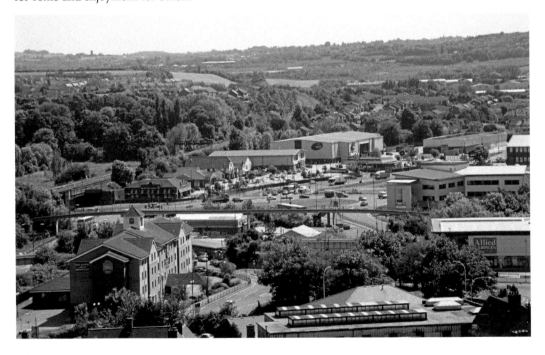

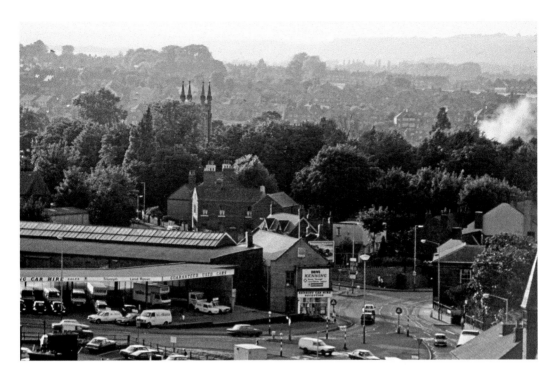

View From 'The Crooked Spire'

Looking north-east we have in 1983 a view of Kennings who had the building on the edge of Sheffield Road previously occupied by Cavendish Motors (a subsidiary of Kennings) with the open car sales area by its side. The filling station canopy still exists but it now covers a hand car-wash area. The edge of the Ryland works can also be seen, which is another site that has been redeveloped.

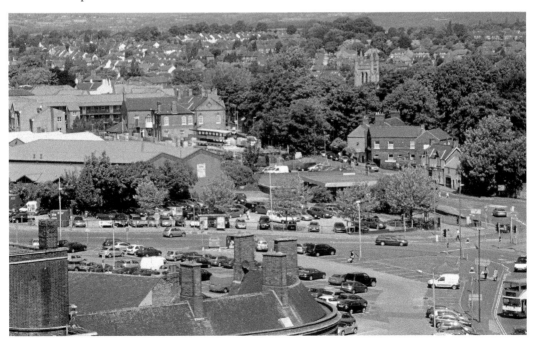

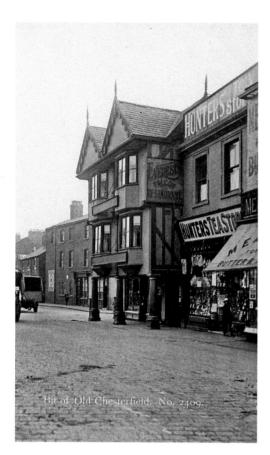

Bit of Old Chesterfield. No. 2409.

Low Pavement

We are all the time hearing of the plight of the public house and how large numbers are closing. At the turn of the previous century there were about 100 public houses in the centre of Chesterfield and over two-thirds of those have disappeared over the years. This was the number in the centre of the town only and did not include those beyond West Bars to the west and Sheffield Road junction with Newbold Road to the north. 111 public houses were listed in 1917 in the whole of the town, of which 15 were along Chatsworth Road, so there had been a radical reduction during that decade.

The Falcon public house on Low Pavement is still with us as a building, but by 1917 it was no longer listed as a pub, and I have some photographs that show it as a restaurant. All that has now changed as the Barnsley Building Society now occupies it, and it may soon change again as they have been taken over by the Yorkshire Building Society.

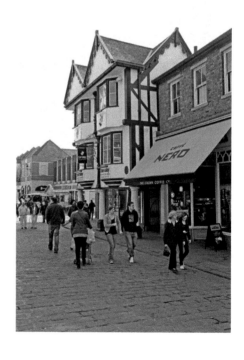

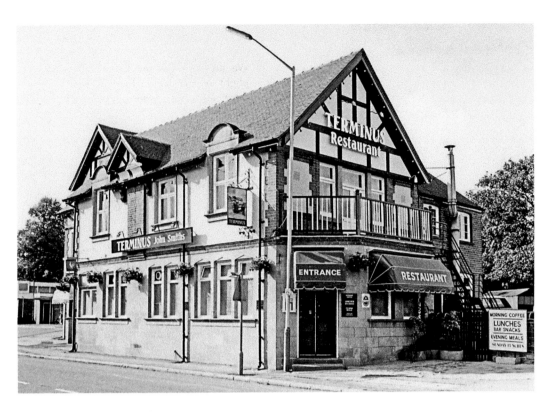

The Terminus Hotel

The Terminus Hotel existed in 1917 as it was the terminus for the horse-drawn tram, but that had replaced the Pheasant Inn (inset). It served the public for many years but then faced the realisation that beer trade could not sustain the large building. When I used it, it was in need of a complete refit inside to make it desirable. The site is now occupied by private flats for the over-50s.

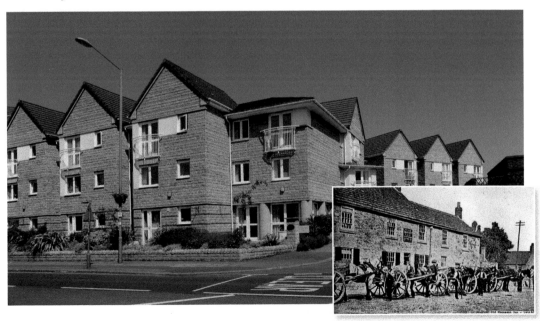

The Lock Keeper

Whilst some public houses disappear new ones are being built. One of the new ones is quite hidden but, nevertheless, it is thriving as it is providing food, the conventional drinks and it also has accommodation as part of the development. The Lock Keeper does back onto the Chesterfield Canal but is hidden behind the present Tesco store and a large number of trees. The site had been a scrap yard for old cars and I had visited it one Boxing Day, when I wanted to get out and get some fresh air, and it was open and we were allowed to walk around and take photographs.

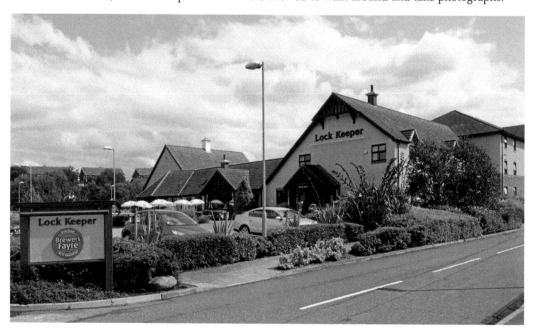

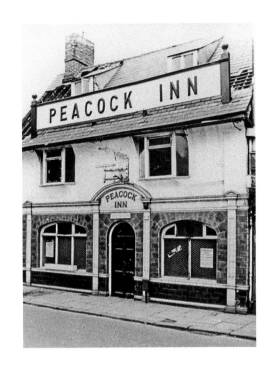

The Peacock Inn

I cannot not include in this section one of our historical buildings. The Peacock Inn opened in 1929 as a public house and ran until it was partially damaged by a fire in 1974. In the restoration it was found to be a timber-framed building and is believed to have been built about 1500, fulfilling various uses from being a Guildhall to a domestic house. It has been used in recent years by the Tourist Information service and has an upstairs exhibition area. It is now a coffee lounge with outside seating area.

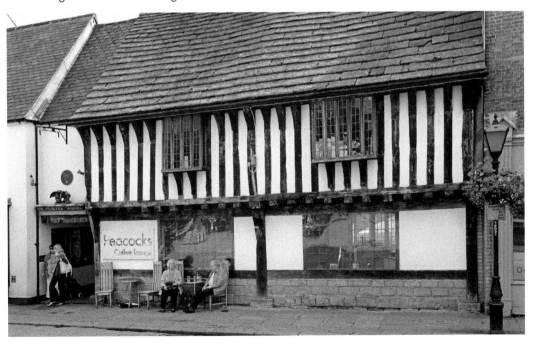

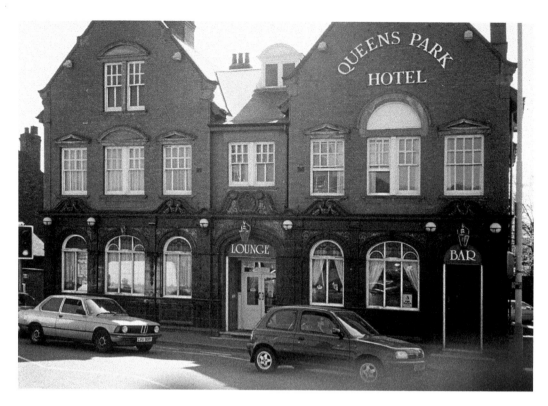

The Queens Park Hotel

The Queens Park Hotel was built in 1913 and was the only public house listed on Markham Road in 1917. This disappeared with the Ravenside Retail Park and the site has altered over the last five years with the construction of the Carphone Warehouse unit and the Pizza Hut behind.

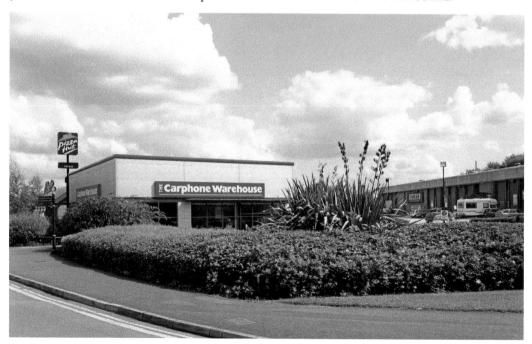

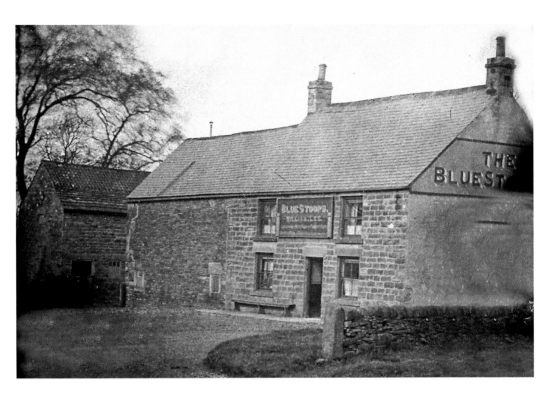

The Blue Stops

One public house that is still with us, although it has been completely rebuilt, is the Blue Stoops at the top of Whitecoats Lane. I pass this frequently and the car park always appears to have plenty of cars in it, indicating its popularity.

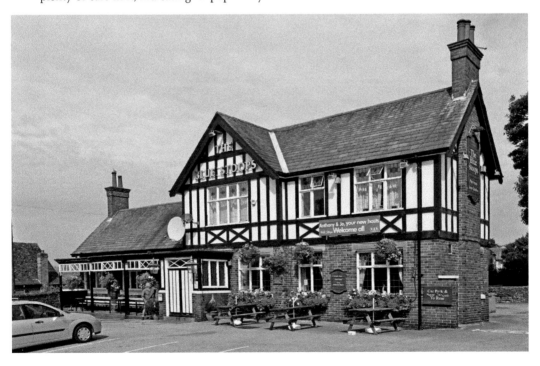

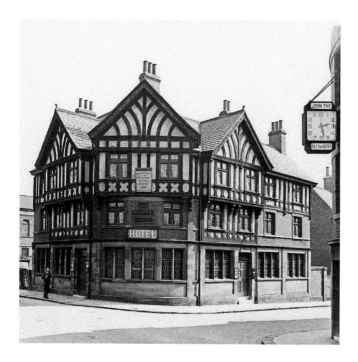

Saltergate

Some public houses change their spots from time to time. One such building is the Thai Pavilion, one of our many Eastern eating establishments. It had been the Manhattan for many years, but this building has change many times having been the Corner House, replacing the Fountain Inn, replacing the Miners Arms. The building is now dominated by the telephone exchange in the background.

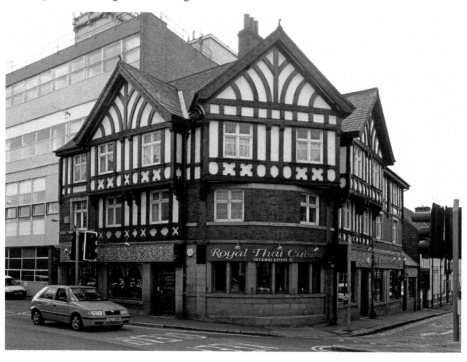

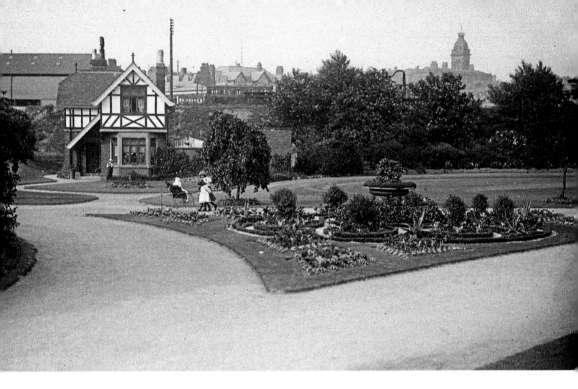

Queens Park

The half-timbered building at the east end of the lake used to be occupied by the Parks Department. The building has been extended and it is now a very pleasant café area with an excellent children's play area, and on warm sunny days it is extremely busy. The flowerbed is still a feature of the area.

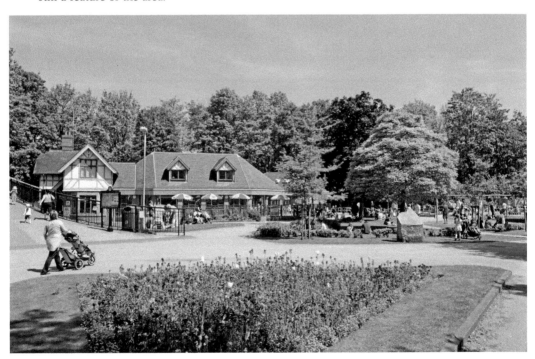

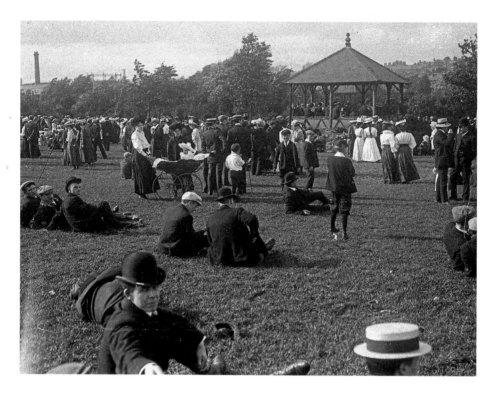

Queens Park

The park was opened in 1893 and dedicated to Queen Victoria. It has been a meeting and recreational spot of the townsfolk since it opened and is still popular. It is used everyday and is also one of the most picturesque county cricket grounds in the country with a few of the Derbyshire matches being played there every year. It is also used for concerts and fairs.

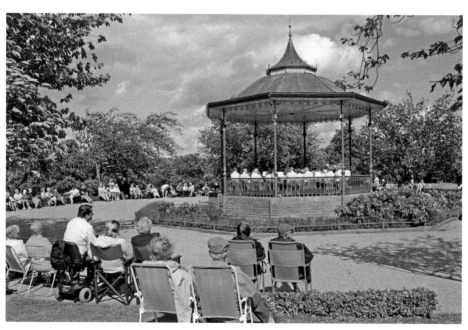

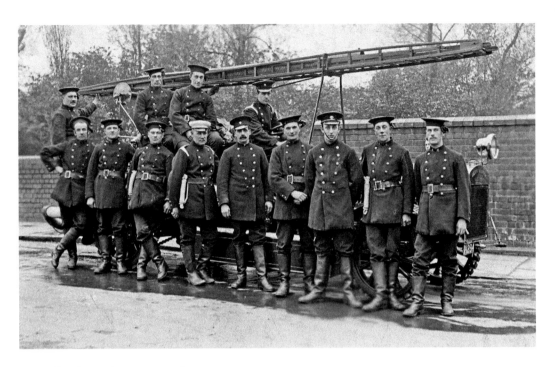

The Fire and Rescue Service

I had two old photographs of fire fighters standing by an engine, both featured the same engine and one had a date of 1911 on it. I approached the service and they agreed to me photographing a current watch against a new vehicle. The one shown is not yet in service as it was with the station for the fire fighters to be trained on it before it became operational. The current engine with ladders is clearly seen on the next set of images, and it is impressive to see the amount of equipment these people carry in order to undertake their role in fire and rescue.

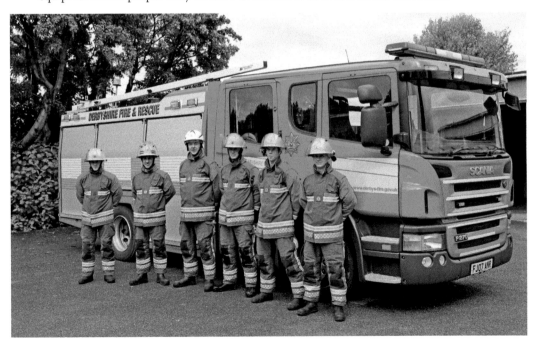

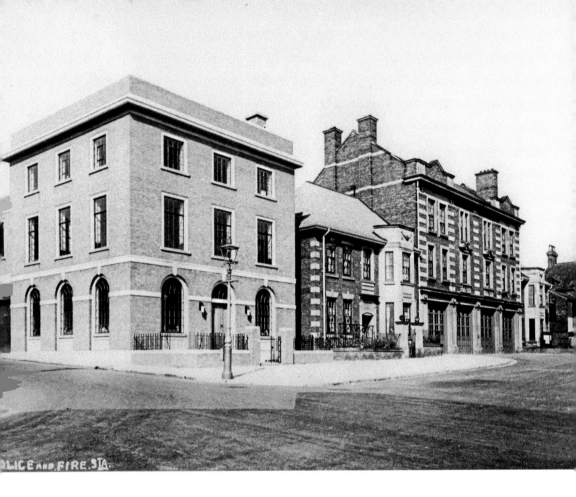

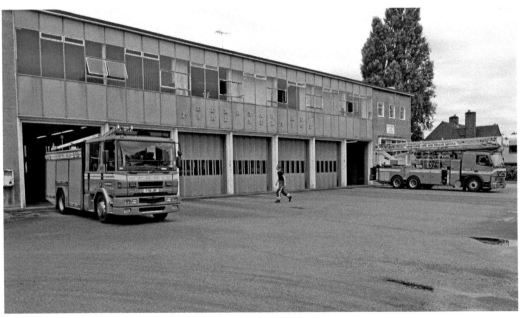

70

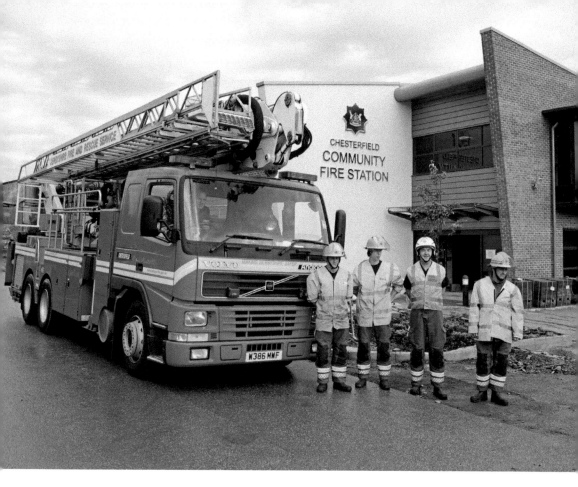

Fire Stations

The Fire Station in Chesterfield has moved around quite a lot over the years. They were towards the centre of the town in Beetwell Street in the same building as the police, although they had moved away before the site was redeveloped. The Fire Service then moved out onto the Sheffield Road site on the edge of the old racecourse, into a concrete-framed building that is now looking very sorry with parts of it being propped up. A new building is under construction behind the new B&Q centre on the old Bryan Donkin site and will be completed for them in September 2009, becoming operational later in the year.

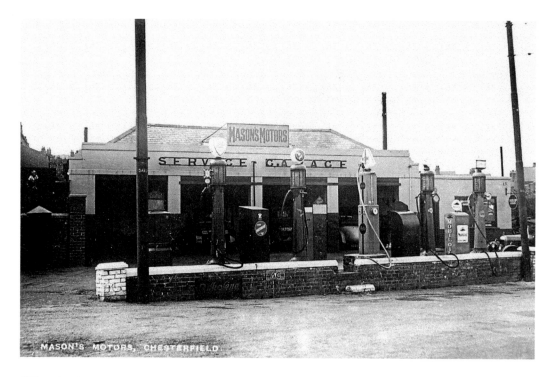

MASON'S MOTORS, CHESTERFIELD

Filling Stations

Filling stations are something that we use on a daily basis without giving them a second look. It is a place where we take the car to fill the tank and pay very large sums of money for the privilege. Although the tanks on modern cars get bigger every year, one of my first cars I could fill from just below a half tank with four gallons for £1.00 total. The service stations now try to encourage more money from your pockets by being mini supermarkets and even Tesco are now getting concessions on the forecourt. When Masons were trading they had an attendant who came out to fill the car and wash your windscreen. Today the attendant will not even leave her seat and you may be lucky to find some water to use on the windscreen.

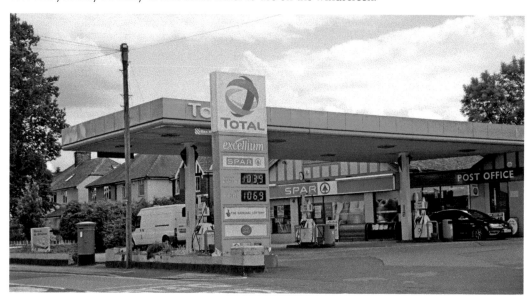

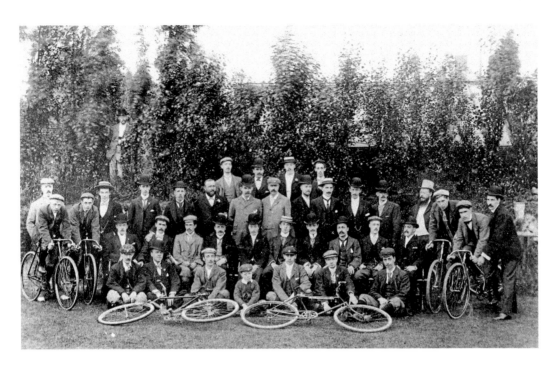

The Spire Cycling Club

Cycling has always been a very popular hobby and it is in the cycling club in Nottingham where I met my wife. The club in Chesterfield, the Spire Cycling Club, was well established at the time of the first photograph in 1899 having been formed in 1888. They are still meeting with runs being organised twice a the week and twice at weekends. What is interesting is the comparison of the clothes and bikes over the last 110 years. The shape of the bikes has not altered but the attire has. Safety is now a very serious consideration, with helmets being standard and the bright colours making the cyclist stand out so that they can be easily seen by the other road users.

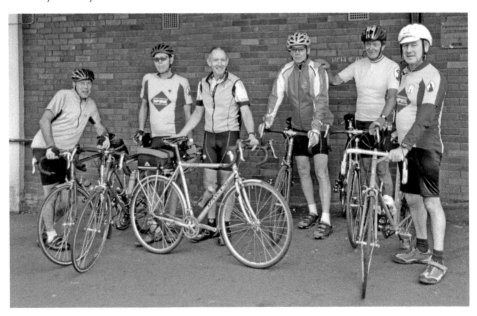

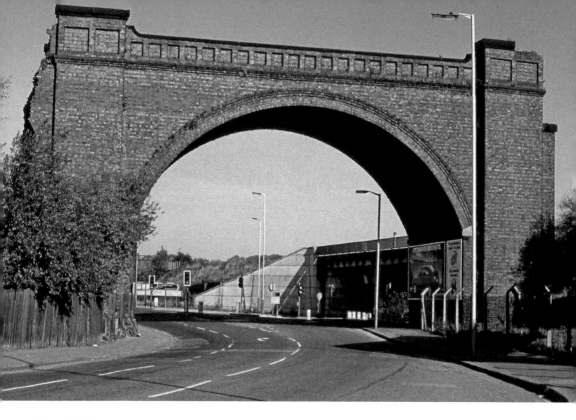

Horns Bridge

To the east side of Derby Road was what everyone called the 'Tube Works'. Although owned by Tube Investments and officially called TI Chesterfield it was the first site to be completely demolished and turned over to part retail, with the motor showroom and the Alma leisure park. It is a hive of activity with fitness suites, food outlets, a public house and a cinema – something for everyone. The motor showroom is now closed and I decided against another photograph of an empty unit albeit at this time boarded-up.

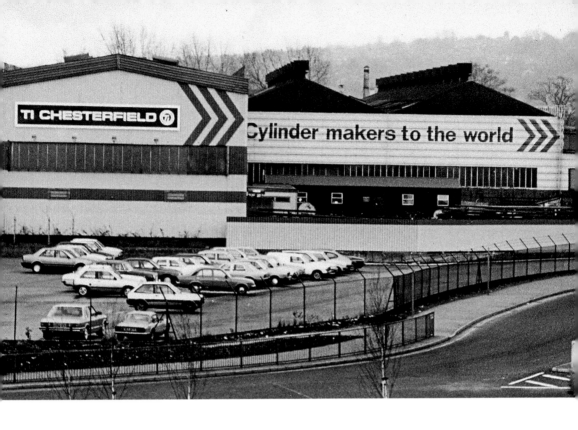

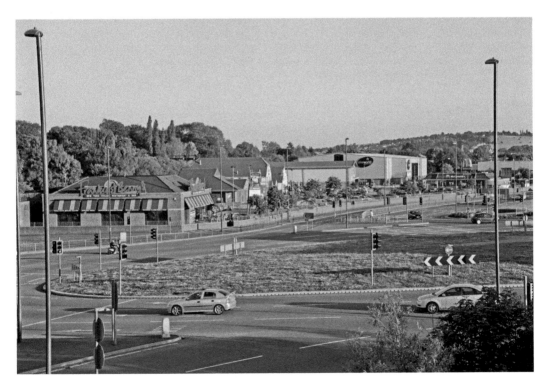

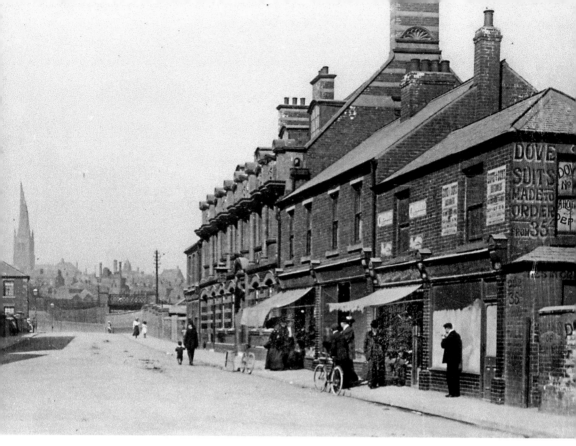

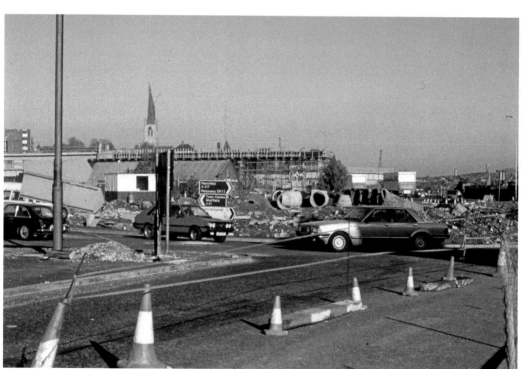

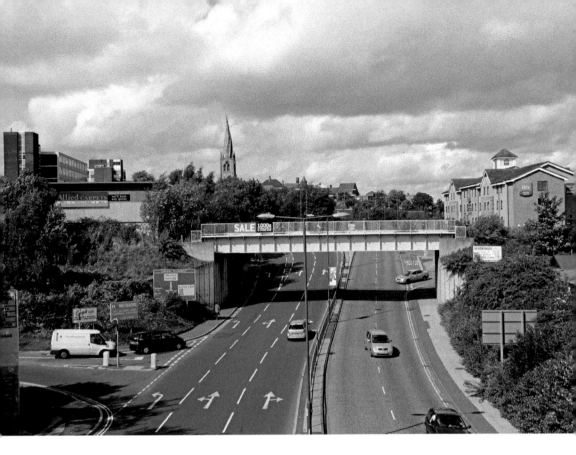

Lordsmill Street / Horns Bridge

The area took it name from a hotel called the Horns Hotel which stood on Lordsmill Street and although it was demolished many years ago, the bridge was always called Horns Bridge. Even though most of the original has now been swept away it still retains that name.

The approach into the town from the south has always been up Lordsmill Street although the actual line of the road has altered over the years. The 1900 image shows the original line up to the town with the crooked spire to the right of centre and the Horns Hotel which was closed in 1970 when the area lost its symbol. In the 1980s it was an area of congestion, with the major roadworks for the bypass being built, and then again recently with the alterations to the island for the old Bryan Donkin site redevelopment. The current picture also shows the Ibis Hotel, which has been fitted in on a postage-stamp sized site!

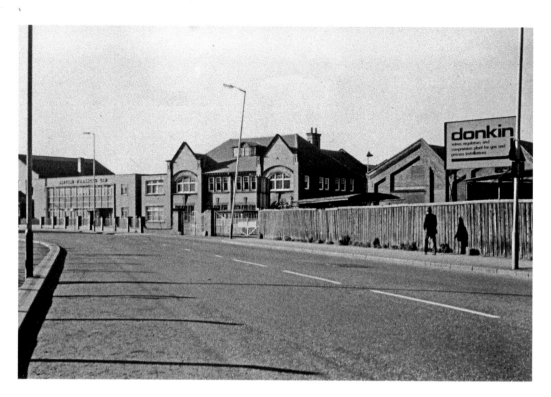

Derby Road

Bryan Donkin was the last of the two of the two factories to completely disappear, although parts of it had started to disappear or had been derelict for some time. The rear of the site is still being built on, with the residential development, but the frontage is complete with blocks of flats that have been advertised as investment opportunities for rental. A sign of the market is that they were guaranteeing the first years rent, but no guarantee after that!

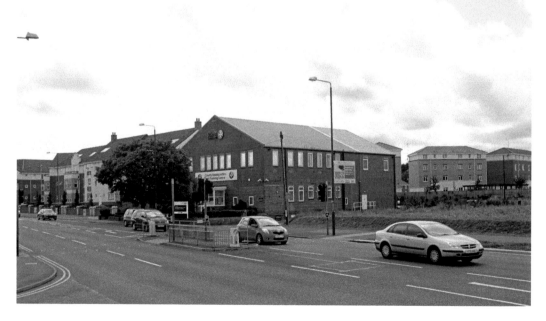

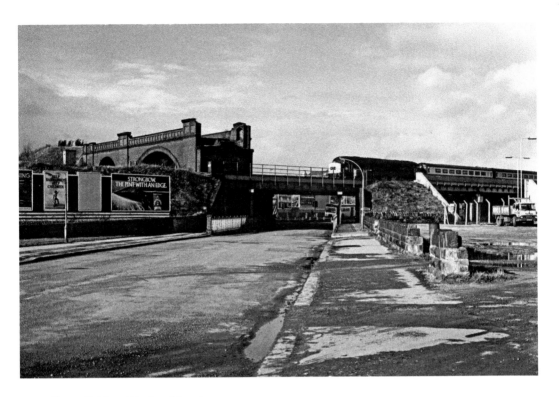

Horns Bridge / Hasland Road

The old bridge was still partially there in 1981 but it was not to be there for much longer. This view is from the Hasland side, and it shows the main Midland main line and how the old bridge dwarfed it, that line went over the current railway. The main Mansfield Road no longer goes to the junction, it is now blocked off with the road being diverted onto the Hasland bypass. This runs along the line of the third of the three railways that used to cross at this location.

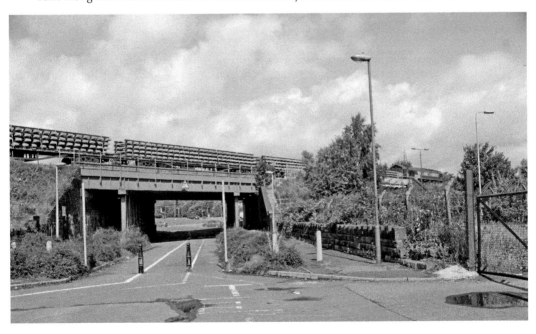

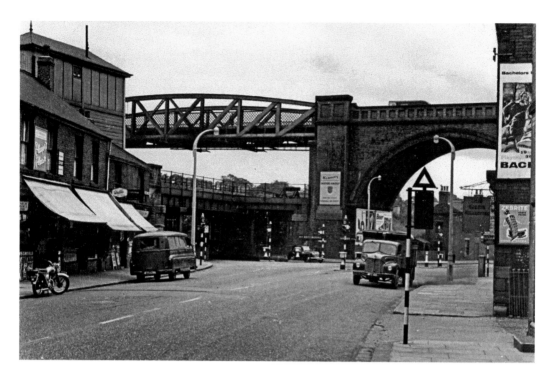

Horns Road

The congested junction is clearly seen in this 1959 image with the truck approaching the town from the Derby Road with the Mansfield Road branching off to the left. Advertising was less controlled in those days with an advert for the Kenning Group on the old bridge and one for Players cigarettes on the building on the right. This whole area has now been cleared with the first of four office blocks standing on the area, although it is only partially occupied.

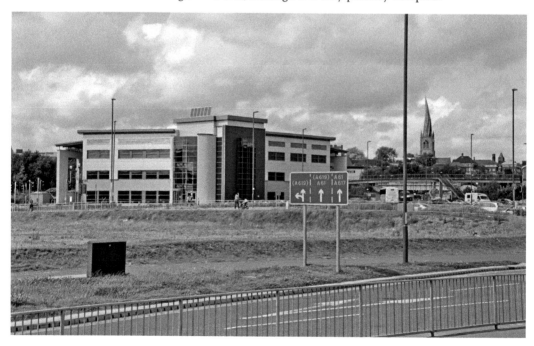

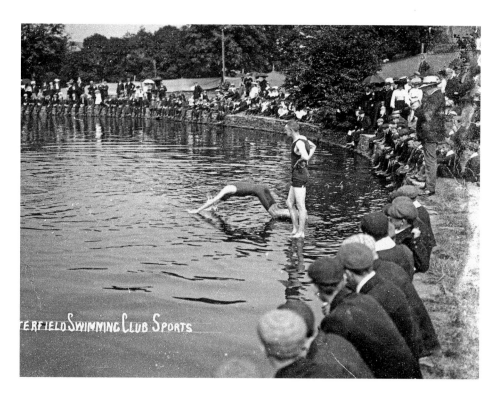

Walton Dam

Walton Dam is part of the Robinson's complex originally used to supply the factory with water, but now it is a recreation area being part of their sports ground. The swimming club no longer hold their galas there as they did in about 1920; in actual fact swimming is now prohibited. It is now a popular dog walking area with the cycle path from the town passing along its northern edge.

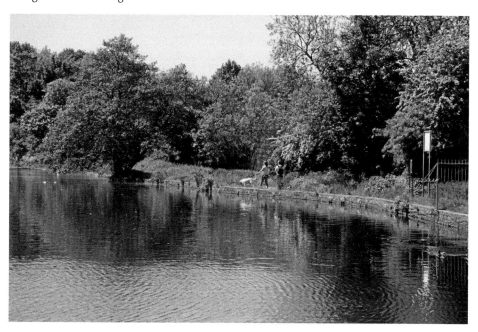

The Glass Works Site

Another heavy industry that has disappeared is the Glass Works at Whittington and the whole of the site has been demolished. A Tesco Extra store is currently under construction and is due to be opened just before Christmas 2009. The new football ground is also to be constructed in the same area.

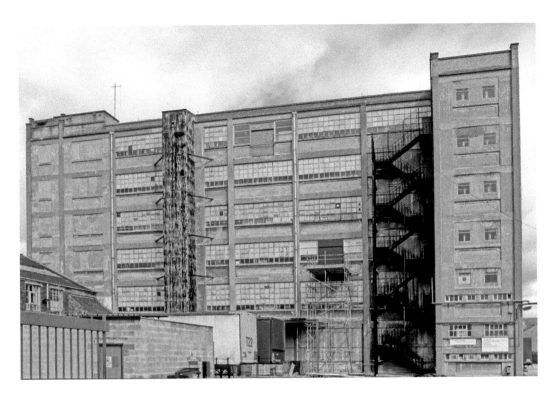

Chatsworth Road

One of the major industries in Chesterfield was and still is Robinson's, although the size of the factory area has now considerably reduced from its previous glory. This concrete block dominated the townscape as you left the town going west along Chatsworth Road. Close by on their site has now been built the new Health Centre, with the area behind still to be developed. One end of the centre has a large mural, which is eye-catching initially, but I feel will become dated in a few years time, just like the old checkerboard panels on Burlington Street which have now been covered up.

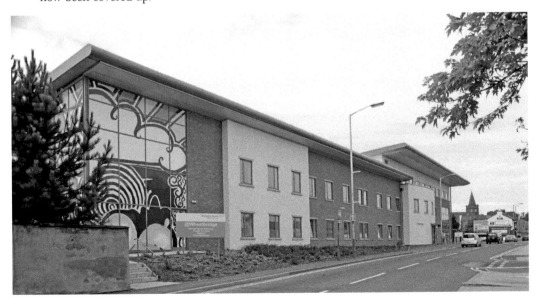

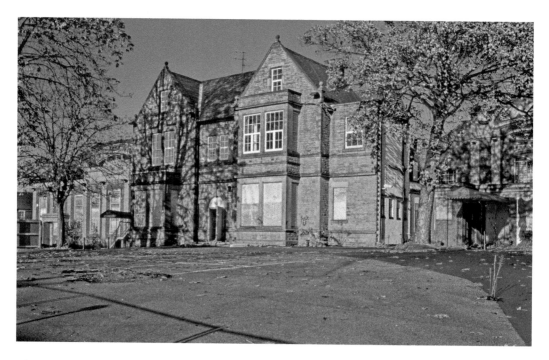

Chatsworth Road

Another of Robinson's properties was Bradbury Hall, which had been the social centre for the firm. It was also used as a feeding and government-issuing department during the war. It had a very large ballroom and I attended many dinner dances in the building when I was part of the Junior Chamber of Commerce. It has now been replaced with another block of flats, which are again being sold as investment opportunities.

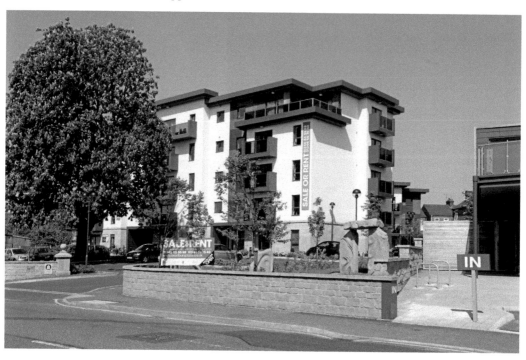

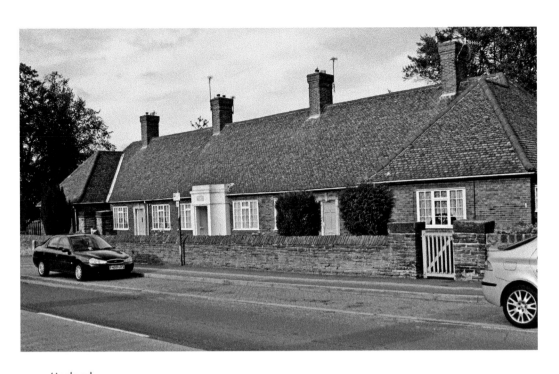

Hasland

Bernard Chaytor Lucas built the Almshouses at Hasland in 1928 as a memorial to his mother. They were replaced in 2005; I photographed them in October 2004 when I was told that they were to be demolished. A new group of bungalows have been built all around a courtyard. This is far more pleasing than the old row that fronted straight onto the street.

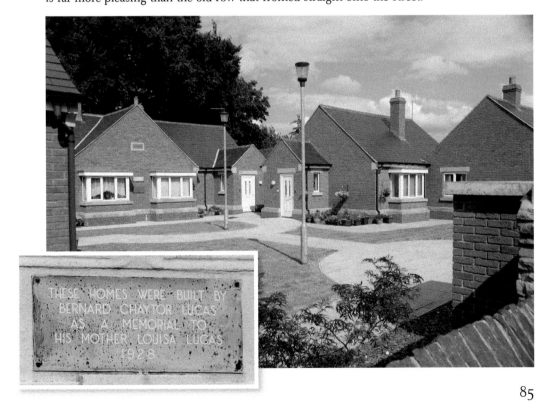

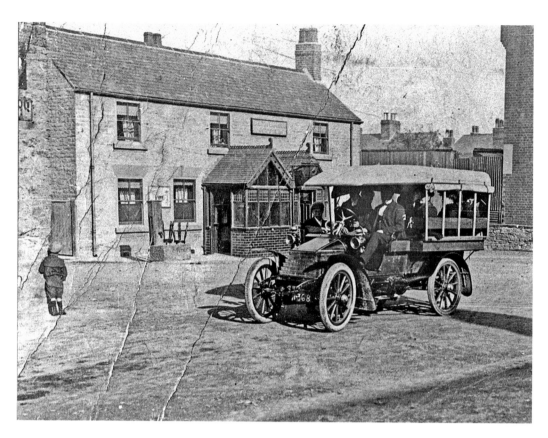

Hasland

The Devonshire Arms at Hasland was listed in 1917 as having Albert Bell as the landlord. It was also the stopping point for the local bus which appears to have been well patronised. The pub has been rebuilt and buses still pass by on a regular basis.

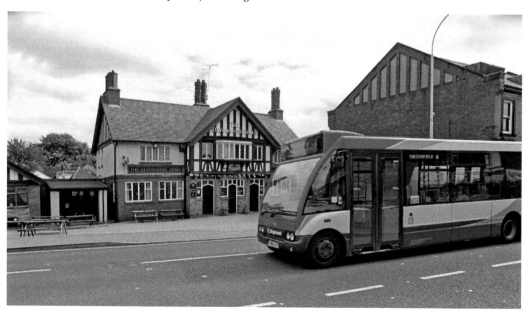

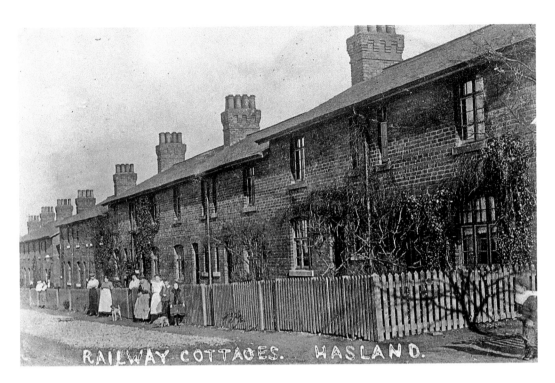

Railway Cottages, Hasland

The railway cottages at Hasland are only separated from the railway by a narrow road and it would appear that quite few of the residents came out in about 1920 when the photographer arrived. Photographers at that time were unusual and a novelty. They are now known as the Midland Cottages and have been rebuilt; from the design it would appear that this was some time in the 1930s.

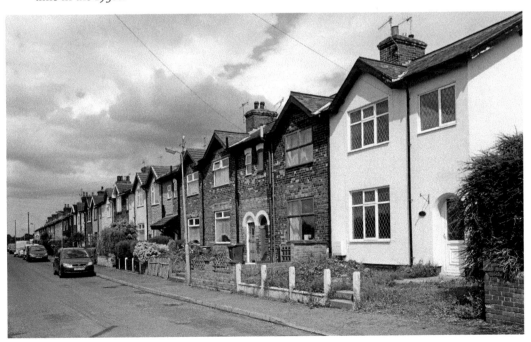

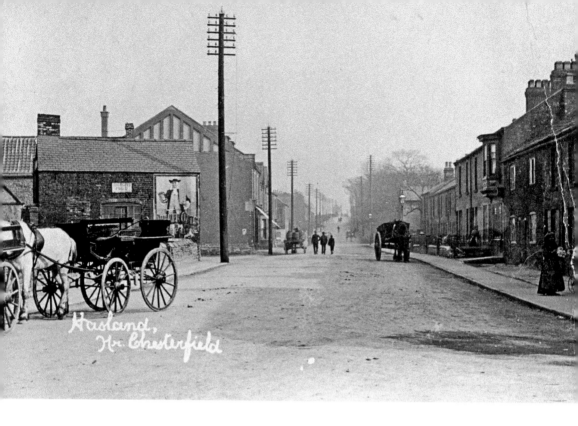

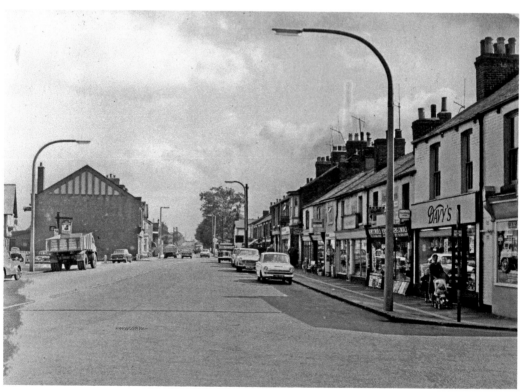

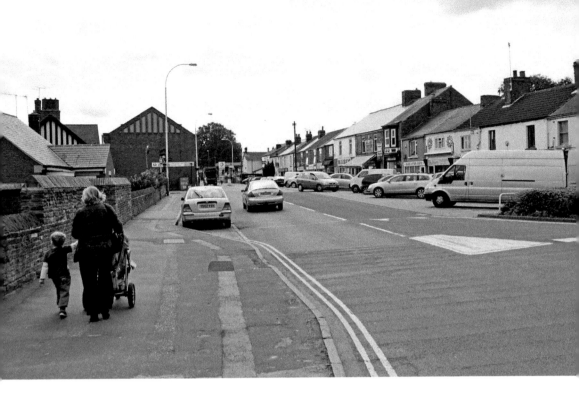

Hasland

The road layout of Hasland has not altered over the years, and the similarity of the overall street scene from 1907 to the present day is remarkable. In 1907 it comprised mainly domestic houses but a large number of these had changed by the 1970s to become retail shops; this number has increased with the actual width of the road now being restricted, with the end-on parking bays.

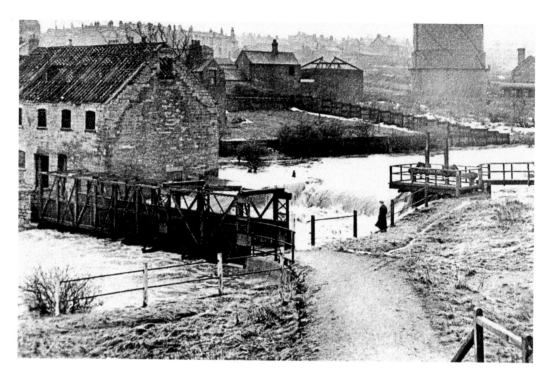

Staveley

Staveley has now been taken into the borough. The steel and chemical works have dominated the area between the main part of the borough and Staveley, but like all heavy industry it is in decline, and large parts are now reverting to woodland. This is clearly shown at Mill Green, the road to which is now dominated by the large Morrisons superstore. The works and the old mill have gone, leaving the fishermen to fish the river.

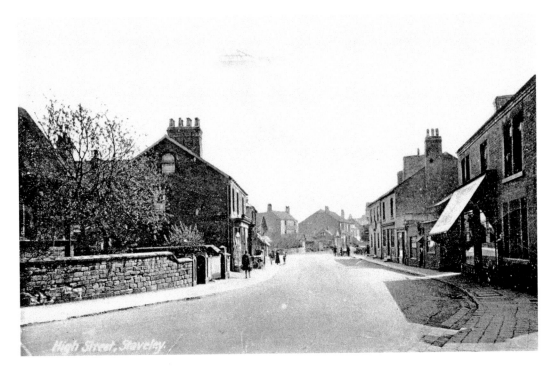

Staveley

The High Street has not altered dramatically over the last sixty years although there has been quite a lot of redevelopment, following the same street pattern. It is no longer a through road and so has reverted to a semi-rural charm, with seats for the retired to relax at on warmer days just outside the modern image.

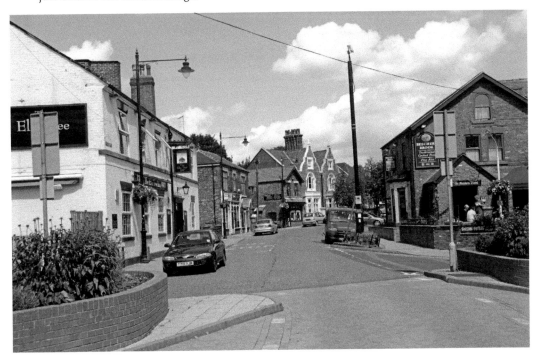

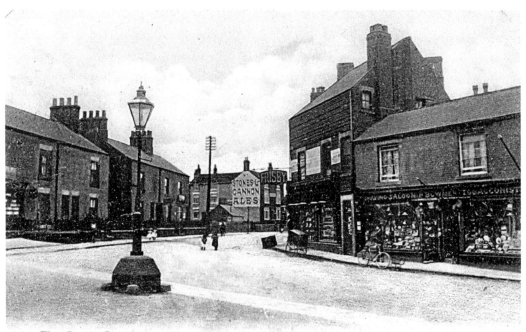

The Cross, Staveley

Staveley

I was advised by a group of pensioners sitting in the seats on the High Street that the Cross used to be at the junction on the main road to Chesterfield. It is now only a stump and has been relocated to the churchyard (inset). The old position is now a bus-stop and on the very busy road between Chesterfield and the motorway. Although the public house site remains, the building has been rebuilt and it no longer sells Cannons Ales.

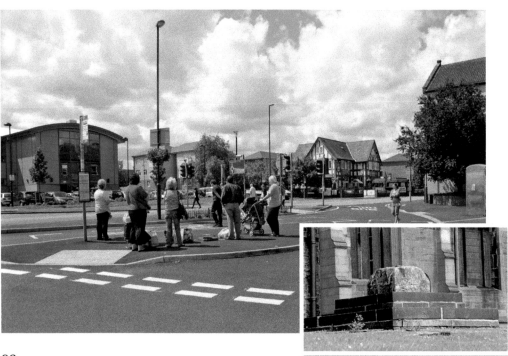

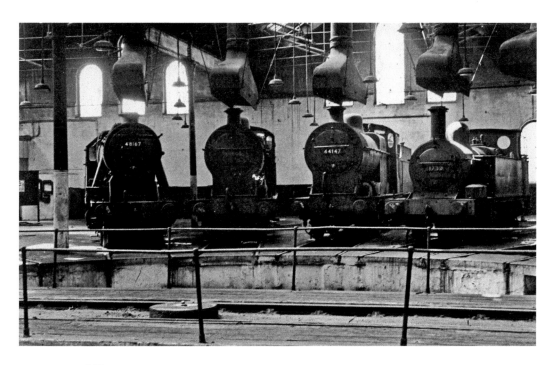

Barrowhill

We cannot leave the Staveley area without visiting Barrowhill. The roundhouse was opened in 1870 and had fallen into disrepair; it has been restored by the Barrowhill Roundhouse Society and reopened in 1991. It is now in constant use again, being used in the restoration of both steam and diesel locomotives and open to the public on gala days when there are many visiting working steam locomotives. In 1965, at the end of the age of steam, it was still a working steam roundhouse and was a dull and dirty building. It is now brighter with the new roof that has been installed with the help of the Chesterfield Borough Council.

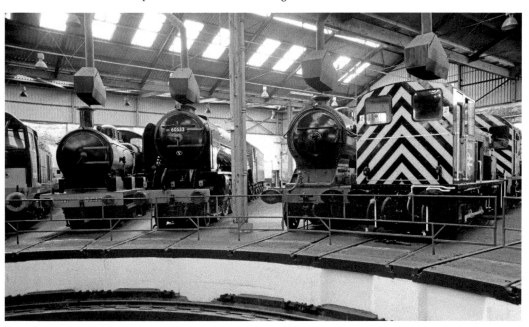

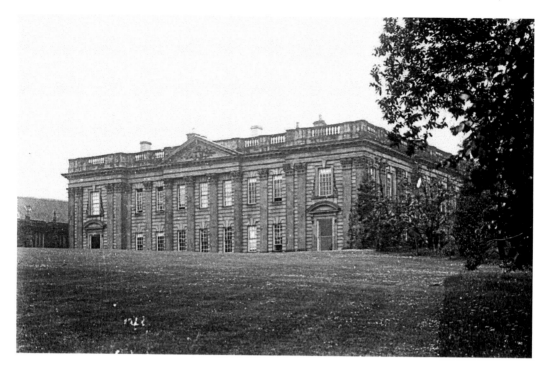

Sutton Scarsdale

Sutton Scarsdale was built in 1874 and has an excellent view over the valley looking east, with Hardwick Hall and Bolsover Castle on the crest. The motorway now runs through the bottom of the valley and there is a good view of the house from just before junction 29 when you are travelling south. The house was still occupied when Nadin photographed it in about 1910, but it then fell into disrepair. It is now a roofless building and is in the hands of English Heritage. It is open to the public at any time.

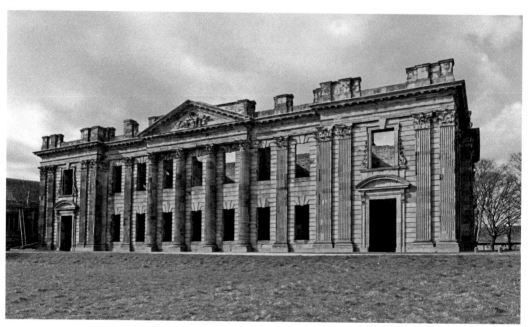

94

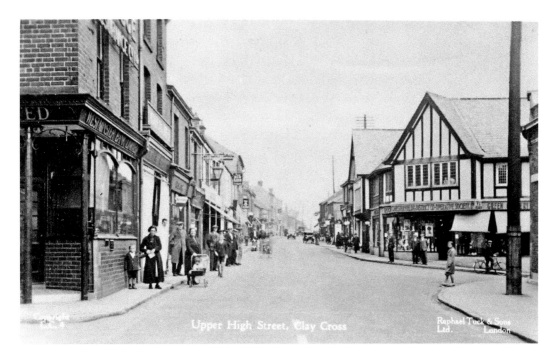

Upper High Street, Clay Cross

Clay Cross

A postcard of Clay Cross clearly shows how the area has altered over the years. The main A61 still runs through the High Street and at busy times it is a queue of traffic on both sides of the road. The area is constantly changing; the building on the left recently changed from a bank to an estate agent.

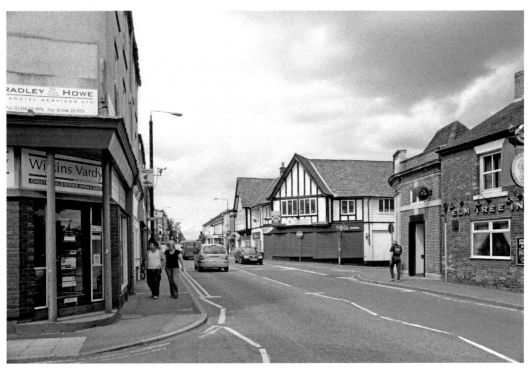

Acknowledgements

Acknowledgements are always difficult as I am always aware that I may miss someone.

I am still aware that Dave Roberts encouraged my interest in magic lanterns and old photographic images, and when he left Chesterfield he gave me all of his collection for Chesterfield and that started my own.

Some of the images come from the large collection of magic lantern slides in the local studies section of the Chesterfield Library. I had borrowed the whole collection to sort out a lecture in the library lecture theatre, and so I was able to use some for the lecture and I was the allowed to use some of them for this book, for which I must give my thanks to Sue Peach.

Ken Davis, another member of the Chesterfield Photographic Society, also supplied me with some images from his collection taken over the last twenty years. I must thank Ken, and also his wife Joan for reading through the draft.

Thanks to Station Manager Richard Barker of Chesterfield Fire Station for arranging for me to photograph one of his watches and also arranging for me to record the new station.

Thanks also go to the Chesterfield Spire Cycling Club for meeting me.

Other photographs have been provided by Mervyn Allcock of Barrowhill Roundhouse Society, and Andrew Littlewood

Finally, I wish thank my wife Shirley for her help, assistance and patience whilst I was working on the draft.